Who Can Stay in the Sky for Long

An Liang
Translated by Haiwang Yuan

Original Title:《谁能在天空久留》

Original book by Baihuazhou Literature and Art Press Co., Ltd

This edition is published by arrangement with Prunus Press USA, through the agency of China National Publications Import and Export (Group) Co., Ltd. All rights reserved.

Who Can Stay in the Sky for Long

Copyright © Prunus Press USA

Written by An Liang
Translated by Hangwang Yuan

First edition 2022
ISBN: 978-1-61612-141-9

Prunus Press USA

Life should sing.

Kindness, beauty, sincerity, and pursuit of sunshine are all worthy of turning into wings of words.

Included must also be the true love for this world and even compassion for humankind.

Poetry can be appreciated in foreign lands like fragrant blossoms, and the desire for peace and perfection can flourish in people's hearts because people share their beautiful feelings.

—**An Liang**

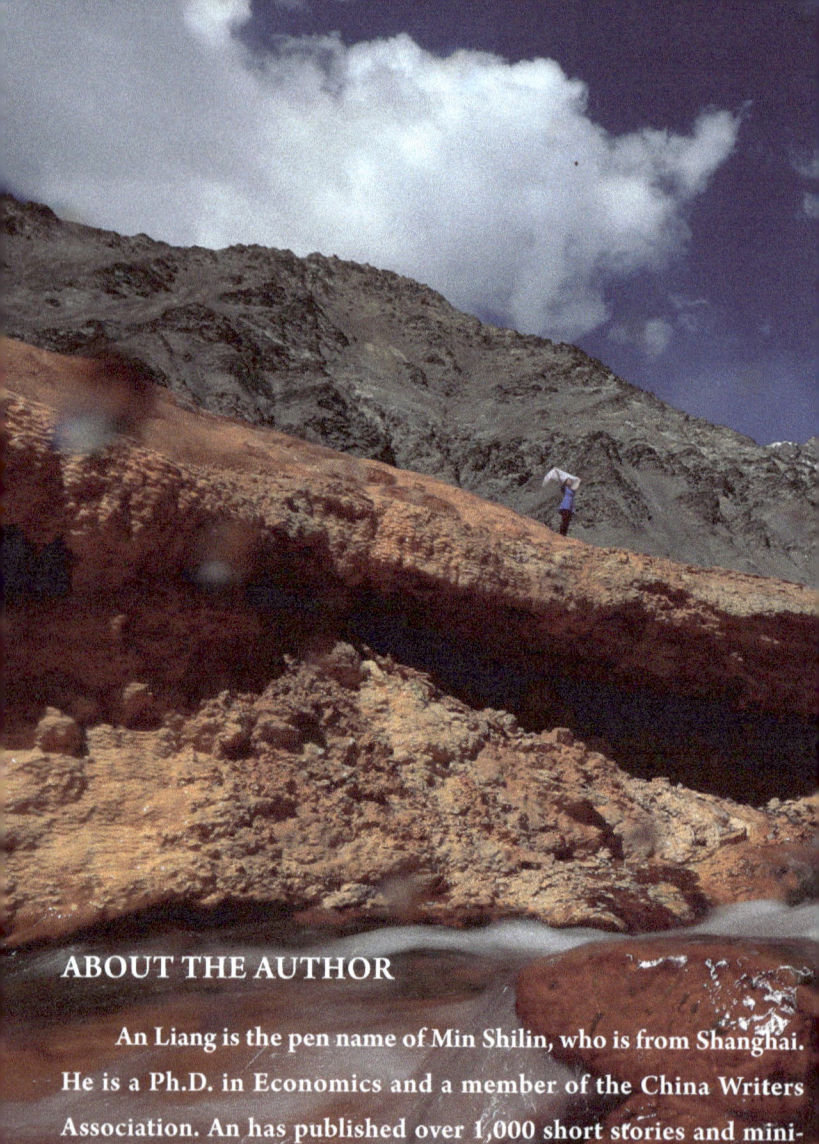

ABOUT THE AUTHOR

An Liang is the pen name of Min Shilin, who is from Shanghai. He is a Ph.D. in Economics and a member of the China Writers Association. An has published over 1,000 short stories and ministories in addition to more than 30 monographs. He has won a few dozen awards and prizes, including the Bingxin Prose Award, the "Mengya" Reportage Award, and the "Shanghai Literature" Poetry Award. He is also the author of full-length documentary literature, musical theater, and modern drama.

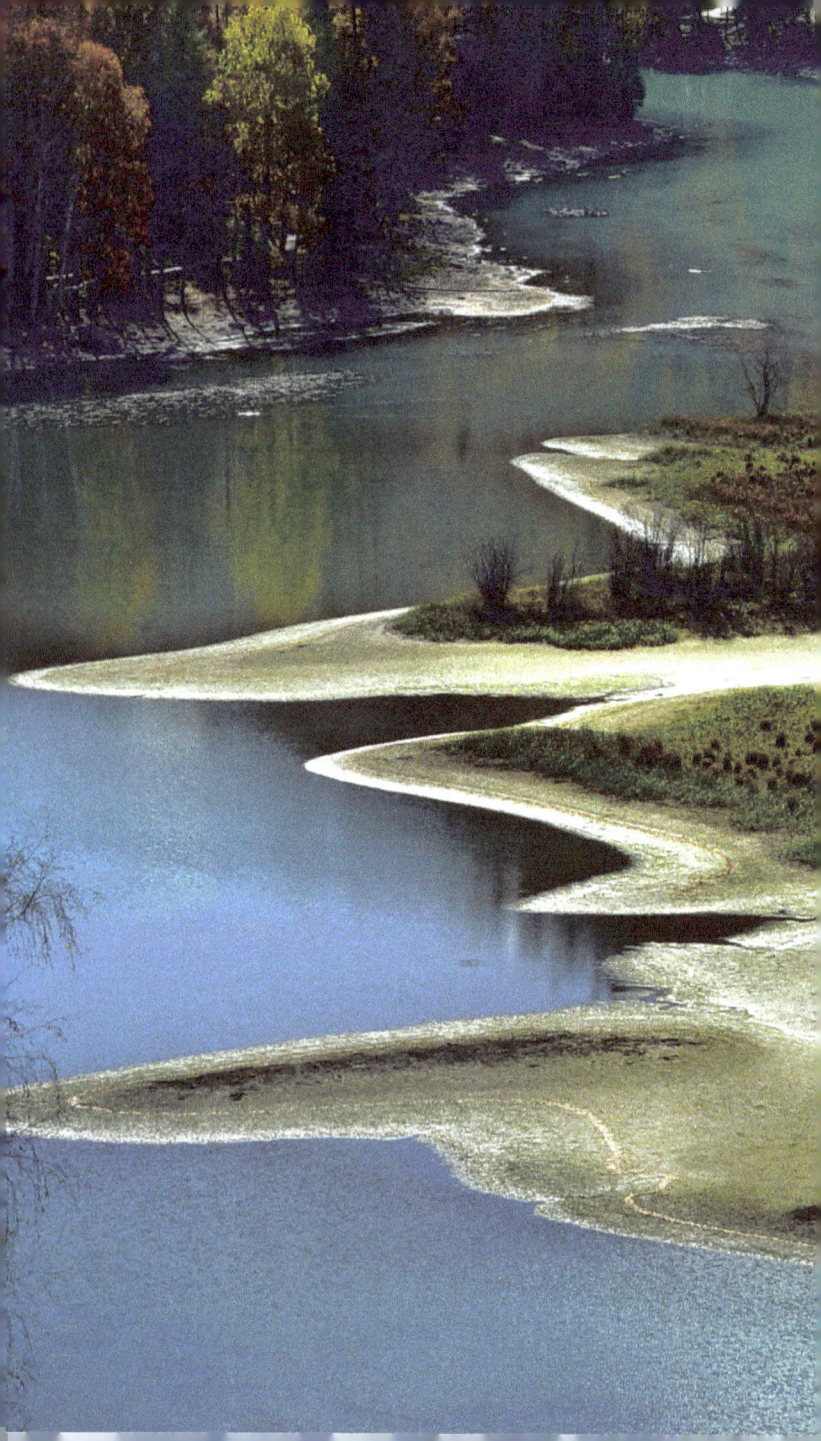

Contents

1	Waiting for the Silver Berry Flowers to Bloom	1
2	If a Gobi Desert Relocated to a City	3
3	Sheep, Disorderly Lines of a Poem	4
4	The Bonfire Is Burning	6
5	I've Heard Some Disapproval of the Gobi	7
6	Showers in the Gobi	8
7	The Gobi Is a Hand	9
8	Since the Gobi Also Wants to Be Ebullient	10
9	Many Years Later	11
10	To Desert Poplars	12
11	A Colorful Sacred Mountain	13
12	A Sparrows' Symphony	15
13	A Small Lake	16
14	Silver Berry Flowers' Fragrance	17
15	Dusty Weather	18
16	The Rain that Fell on April 29	19
17	The Soul Makes a Noble Flight	20
18	The Sky Wearing a Blue Qipao	21
19	I See A Crescent Moon Nearing	22
20	A Magnificent Trill	23

21	Please Lend Me the Platform on the Plateau	24
22	Fencing in the Clouds	25
23	Who Can Stay in the Sky for Long?	26
24	I've Left My Soul at the Far End of the Plateau	28
25	Muztagh Ata's Glacier	29
26	Snow Fog above the Glacier	30
27	Boundary Marker No. 7	32
28	The Glacier's Color	33
29	Avalanches Happen Everyday	34
30	A City Closest to the Sun	35
31	Flying along the Tianshan Mountains	36
32	Beauty of Loulan	37
33	Lop Nur	38
34	My Gobi Desert	39
35	Another Familiar Spring	40
36	Reeds	41
37	The Rain in My Hometown Last Night	42
38	Silence Is the Deposition of a Day	44
39	Autumn Moon	45
40	The Lambskin Hat	46
41	A Mine's Language	47
42	A Private Conversation in Autumn	48
43	A Wind Rose	50

44	The Tianshan Grand Canyon	51
45	Mudslide's Affection	52
46	A Sandstorm Comes Gracefully	53
47	A Yulan Magnolia in the Courtyard	54
48	A Tree	55
49	A Sandstorm Blows to My Hometown	56
50	A Pebble	57
51	Autumn on the Nalati Grassland (Two Poems)	58
	a. Verses Glisten on Grass Tips	
	b. The Emptiness of Autumn Days	
52	On the Empty Stage	60
53	A Sandstorm Is an Urchin Running Wild	61
54	Various Kinds of Strange Forms	62
55	Silence Is Real Gold's Sense of Loss	63
56	The Amount of Sand Is the Word Count	64
57	All the Clouds Fell Scattered onto the Ground	65
58	Lighting Up the Desert with Their Songs	66
59	I Don't Mean Not to Cross This Dead Silence	67
60	The Aging of the Desert	68
61	The Secret of Remote Antiquity	70
62	When Sand and Dust Gather into a Storm	71
63	The Stars at Night	72
64	I Haven't Hiked So Far	73

65	I Still Feel the Sorrows of Metropolises	74
66	It's Said to Be the Site of an Ancient City	75
67	If There Were No Wind as Makeup	76
68	What's the Meaning of Life If We Walk Like This?	77
69	What's Behind This Desert?	78
70	Snowflakes in 2008	79
71	In an Affectionate Manner	80
72	It's a Boundless Scene of Fire	81
73	Even on the Vast Desert	82
74	The Highway Is Too Long a Painting Scroll	84
75	Mazars Are Like Offerings Arranged Orderly	86
76	A Saddlebag that Belongs to the Modern Era	87
77	A Pious Kiss	88
78	A Millennium of Silence	89
79	The Desert and the Mountains	90
80	Sharing the Characteristics of the Desert	91
81	Camelthorn Is the Desert's Tears	92
82	Shifting Sand	93
83	A Highway in the Desert	94
84	Standing on the Edge of a Desert	95
85	I'll Borrow a Day's Snow from North China	96
86	I Miss the Sea Where It's the Farthest from It	97

87	Being Briefly Distracted	99
88	The Character of a Man of Virtue	100
89	Passing by a Tree	101
90	The Sound of Cracking Ice	102
91	Millennial Trees in the Tianshan Mountains	104
92	The Bachu County Fossil Gully	105
93	Traversing the Heizi Gobi Desert	106
94	Golden Desert Poplars	107
95	Fragmentary Thoughts on Finding Jade with Feet	108
96	May in Kashi	109
97	To a Kind of Urban Birds	110
98	The Eagle Flute	111
99	Falling Apricot Blossoms (Cycle of Poems)	112
	1. Beauty Is Also a Kind of Loneliness	
	2. So Dimly Discernable a Figure of a Beauty	
	3. Sorrows of Spring	
100	Snow in a Strange Land (Cycle of Poems)	115
	1. My Homesickness Is Piling Up	
	2. I Want to Bring a Handful Back	
	3. Led by the Snow of a Place Not My Home	
	4. Bleached Long Night	
	5. Running Like Sheep	
	6. Like My Childhood Buddies	
	7. Who Can Read the Confused Mind of a Strange Land's Sky	

8. There're on Land as Many Sojourners

101	A Moving Mountain	124
102	Bosten Lake	126
103	A Yardang	127
104	Putting up the Night in Shache	128
105	A River Traversing the Gobi Desert	129
106	A Flock of Sparrows	130
107	Snowflakes	131
108	Spring of a Thousand Tears	132
109	The Lost Harvest	134
110	The Remaining Purity	135
111	Lake of Dream	136
112	The Figure of a Spotted Deer	137
113	*Chuer*'s Dream Groans	138
114	A Lake with Six Bends	139
115	As Noble and Unsullied as the Sky	140
116	Heavenly Lake of Tianshan (Cycle of Poems)	142

 1. An Elm Grove in Summer
 2. The Surface of Tianchi
 3. Those Loitering Clouds
 4. It Takes Me for a Tuft of Cloud
 5. Snowfield Buick

001
WAITING FOR THE SILVER BERRY FLOWERS TO BLOOM

They say her pleasant odor,

Once intoxicated an emperor.

At the end of each April,

She blooms again in splendor,

Her scent lingering further.

Standing at the Gobi desert's end,

For a long time, I'm gazing at her.

It's March, but still like a country girl,

She's frolicking in a carefree manner,

With an old elm and a young poplar.

But she doesn't think it bothers her.

A man came from the south yonder;

His visit seemed unusually earlier.

Something's as beautiful as a flower;

He's expecting it to be even prettier.

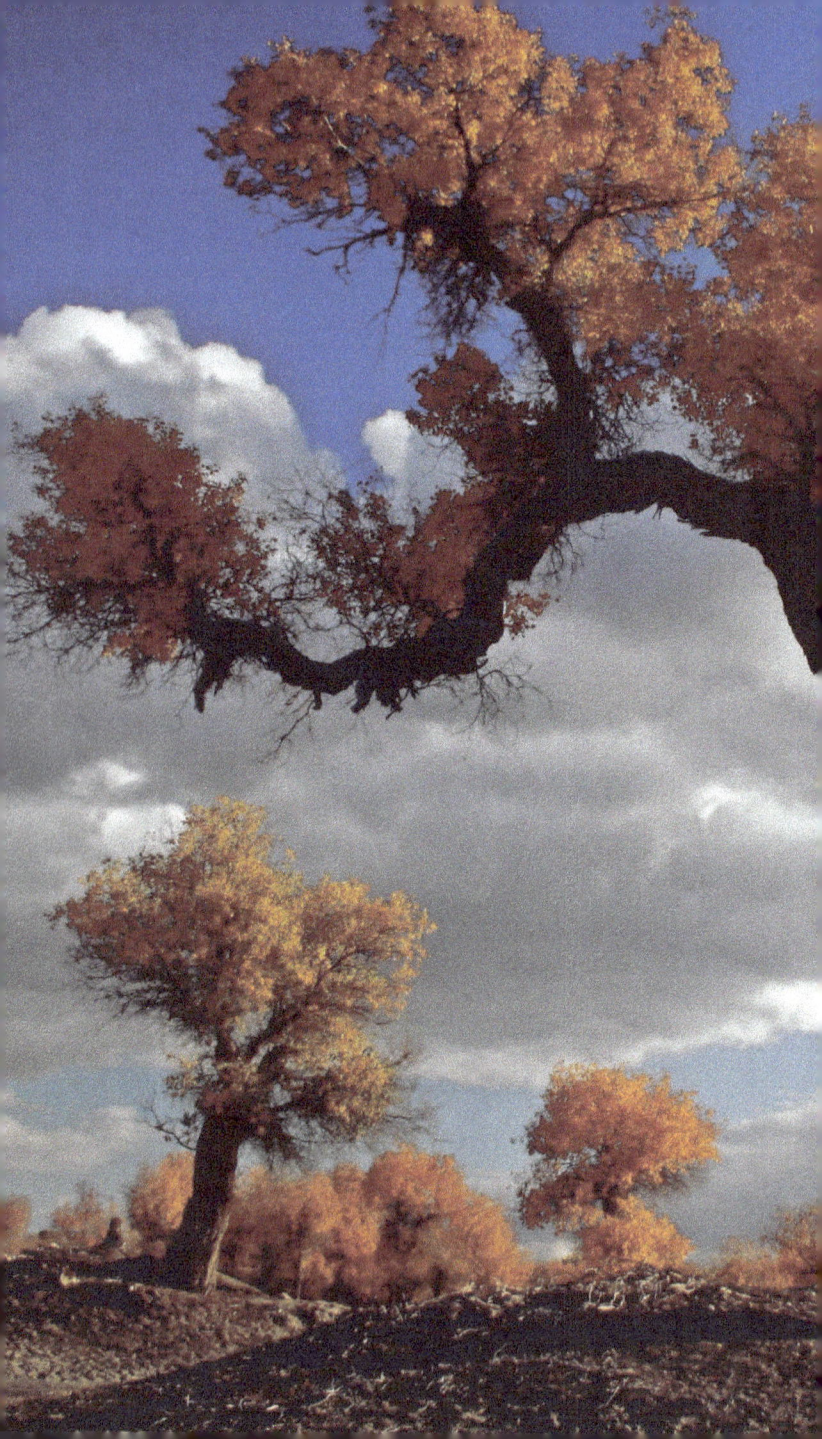

IF A GOBI DESERT RELOCATED TO A CITY

If a Gobi desert relocated to a city,
An urban landscape that the Gobi would be,
Making me who's accustomed to high rises
Think deeper with blood boiling in me.
Oh, the Gobi, as pristine as you can be,
You're an expansive virgin land.
You may feel bashful in such a municipality,
Where the hardest thing to find is purity.
Mind you: none can keep intact her chastity.
You may ask, "How to maintain our dignity?"
"The orb of the night alone from antiquity,
Could keep it from being smudgy."
A kind of reticence eerie
Clatters in the city museum of history.

SHEEP, DISORDERLY LINES OF A POEM

On the Gobi desert boundless,

Scatter a flock of sheep listless,

Like the lines of my poems, artless.

Wearing a doppa and carrying a whip,

A herdsman cajoles his animals whistling

To form a cozy community of kinship,

With everyone enjoying family membership.

But I can't drive the lines of my poetry,

Into a yard with a sheepfold.

Neither do I have a wand of authority

Nor aromatic hay that makes the sheep happy.

I have but to sit down in the flock deep

And turn me into one of the sheep.

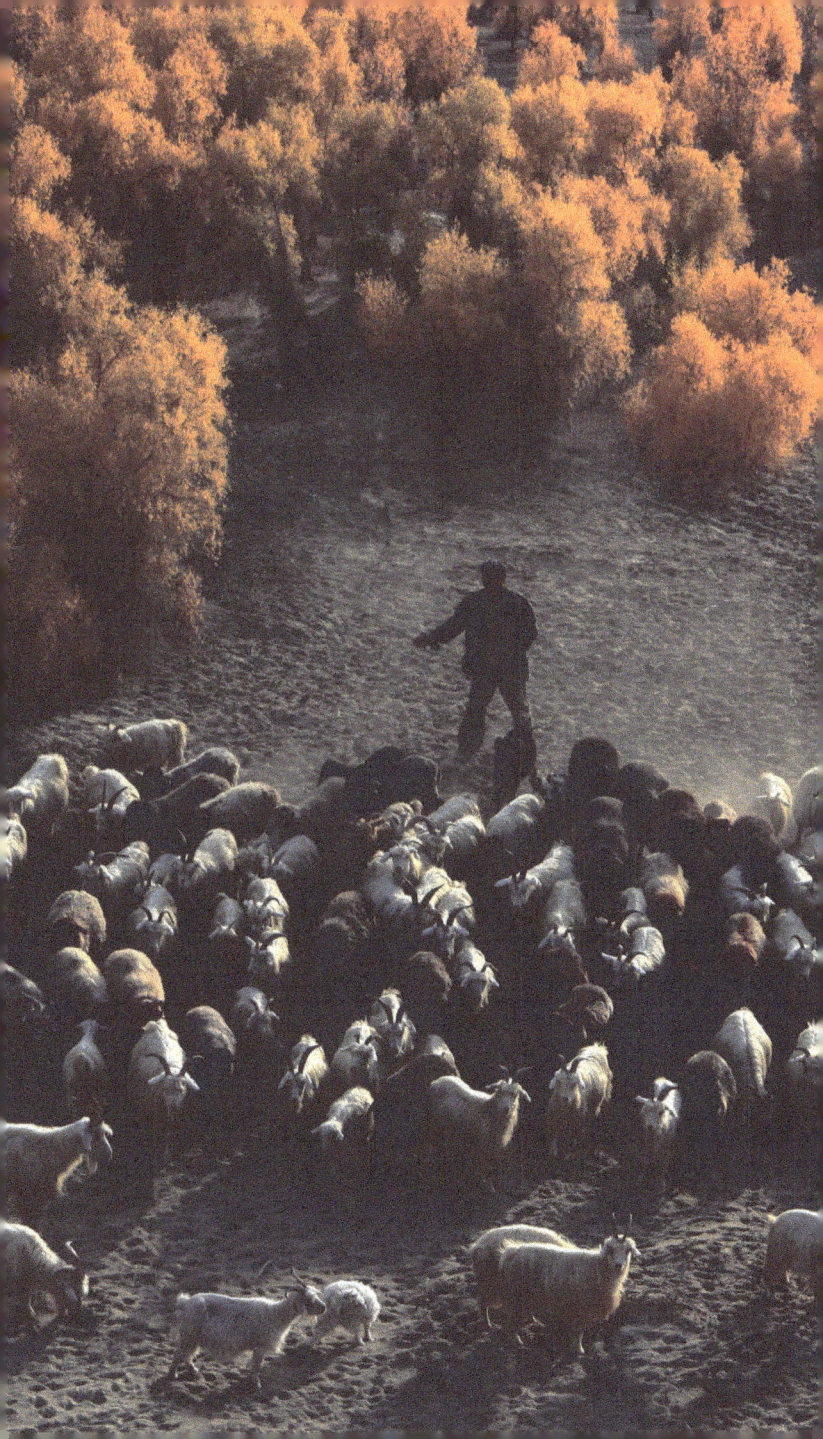

THE BONFIRE IS BURNING

The bonfire is burning,

The poplars are laughing.

On the quiet Gobi desert,

It flares up a vibrant feeling.

Through the earth and the sky, it's burning.

Sparks the bonfire is spewing.

Like comets fleeting,

Happily, into the dark, they mysteriously spring.

Souls vicissitudes of life witnessing,

On the flames of the fire are dancing.

Amidst the rhythmic music crackling,

We can hear our hearts crying.

Tonight, the stars the bonfire is masking,

But all we see is lively spirits glittering.

I'VE HEARD SOME DISAPPROVAL OF THE GOBI

I've heard some disapproval of the Gobi ringing,
Like a drizzle, coming from the south whispering.
It drips caustic onto the leaves of my heart,
But I don't want to spread the remarks scathing.
The Gobi desert and I are like twin brothers,
We're both courageous fighters,
Equally disillusioned with the mortal world.
We're so proud that we disdain to be haughty.
We have boundless compassion for every life,
And the disapproval is embedded in it deeply,
So deep that it seems etched for a millennium.
Let go of that drizzle.
Like a sigh, it'll fizzle.

SHOWERS IN THE GOBI

How can the teardrops you're shedding

back the desert's profound past bring?

It expected you to play your promised role,

Pouring down with force under no control

To cleanse its chest and soul.

It would then allow poplars to grow en masse,

And repay you generously with abundant grass.

But now, its face pale and haggard shrivels,

With its sorrow depressed into gravels,

As it lies endlessly with zero decibels.

A few droplets of tears from you

Can only leave on its greyish cloak some hue,

As does the evanescent morning dew.

After waking up from its fanciful dream,

Where will it wander in its conscious stream?

007 THE GOBI IS A HAND

The Gobi is one hand,

The sky is the other.

They form an empty world

When the fingertips touch each other.

Mud has stained one hand,

The other is covered with sand.

I resemble a drop of water,

Through patterned cracks, seeping deeper.

With its hazy eyes, the sun looks down,

Dust stoops to look with a caring frown.

Seeing the hands of a boy naughty,

Playing with the soil balmy,

I recall my childhood visionary.

When twilight is gradually rising,

The hands above are slowly falling.

I fly away like a bird,

As if mom's call I heard.

SINCE THE GOBI ALSO WANTS TO BE EBULLIENT

I don't think of a landscape as perfectly pretty.

So, I want to measure with my feet its beauty.

The dunes after dunes of gravel and sand,

At the bottom, many lasting dreams must stand.

The cracked dune slacks I won't pass by;

Nor will I the rolling dune fields amplify,

Although the desert appears like the sea,

As surging and raging as an ocean can be.

Since the Gobi also yearns for development,

Let's carefully build it into a palace ancient,

To be enjoyed with the masses with excitement.

Hey, come on, tomorrow!

Inspect your eyes with a chilling glow

My exposed chest as I on the sand throw.

MANY YEARS LATER

I've many wrinkles in my conscience,
And each crevice is replete with
Your tenderness and elegance.
Though cast in the Gobi,
Or buried in the desert,
They can become camelthorns prickly
And salt cedars with extreme pliancy.
Like a boat setting off at night lonely
They're drifting in the memory leisurely,
Into the stream of your dream at night
On the tears as precious as jadeite.

TO DESERT POPLARS

On the saline and arid land,
You're dancing hand in hand.
Your colors change with each season,
To show your defiant stubbornness
Or to express your intense passion.
To me, a man from southern China,
You're a river winding and dancing,
With your greenness, you're surging.
Your luxuriant waves billowing,
Turning the sky into an image painting.
You're everywhere on the Gobi,
With your graceful shadows glittery.
I see you as the genuine poet and painter,
While I'm nothing but a reader,
A greedy one, who can appreciate
Each elegant gesture of your leaves,
Which lithely and leisurely vibrate.

A COLORFUL SACRED MOUNTAIN

I frequently envy the clouds in the sky;

Transcending this world, they freely fly.

But the mountains prefer the earth and

Choose the Gobi desert as their homeland.

Condensing into colorful rocks and crags,

They form the Tianshan range that zigzags.

With its length of a few dozen li,

They interpret their loyalty in eternity.

Perhaps billions of years later,

The desert wind will erode their bodies.

But their mineral elements will never alter,

Because into their bone marrows, they're dinned.

They're the sacred mountains' soul,

Remaining magnificent and colorful,

Even when crushed by nature's anvil.

Oh, humans may not live as long as a mountain,

But thru cultivation, the dignity they must maintain.

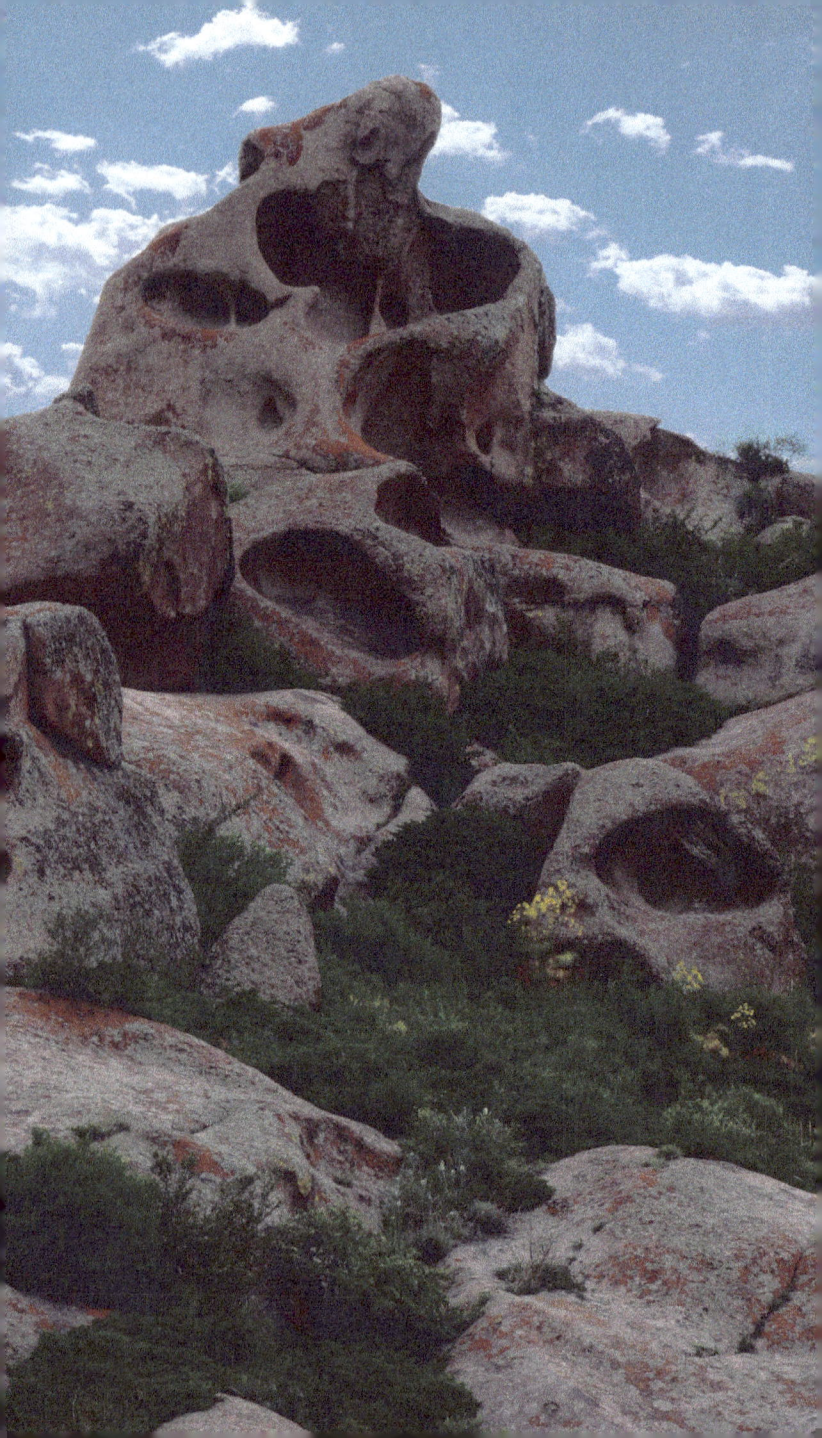

012 A SPARROWS' SYMPHONY

On a quiet and deserted morning,

Louder seems the sparrows' chirping.

On the Gobi desert,

A symphony they're performing.

The crunches of my tires rolling,

Their aesthetic mood I'm not disturbing.

Like the keyboard on a clamorous piano,

The background they're further expanding.

A SMALL LAKE

"Who's planted the reeds in the water?"

In a grove, the willow trees whisper.

It also shakes its head each desert poplar.

A few relic gulls fly over

And peck the surface of the water,

Wrinkling it into waves of a jealous temper.

The wind is howling;

The thin reed is bending.

Harboring its secret consideration,

The levee's lost in deep meditation.

The trail of the setting sun

Looks like Chinese haws stacking,

On the surface of the lake floating,

Gently and gently bopping.

Then it melts into nothing,

Faster than my yearning.

The beautiful scene is but routine,

Day after day, it's what our lives have been.

014
Silver Berry Flowers' Fragrance

A period of unprecedented expectation,

Into a beautiful sea has turned my imagination.

You're as noble as Consort Rong.

Can I come close to you soon?

The barrier between us is called your reputation.

For your early arrival,

I've given up a bundle.

I'm gazing at you with love tender,

Just to greet you with grandeur.

But that day, I ran into you.

You stand slim and delicate,

And your scent is by no means sophisticated.

From your yellow petals,

Love you communicate.

I suddenly find in a happy surprise,

You turn out to be the next-door girl I prize.

Dusty Weather

This season sees floating dust arise,
As light and fuzzy as paper made of rice.
No one knows if it's the fan of spring
Or the companion of the flowers blooming.
Used as a paperweight, the sun
It proves too light to get things done,
Allowing the dust rampant to run.
This season also witnesses
The rise of some dissatisfaction,
Which defies self-possession.
So, daily, with the strength of my verse
I attempt the negative mood to reverse.
I've packaged the adolescence's factor,
Waiting till the sky blues in summer.
Then, I'll use my brush pen like a flying dragon,
To create my calligraphy work with the character.

016 THE RAIN THAT FELL ON APRIL 29

In Southern Xinjiang that specific day,
A sandstorm yellowed its daily record,
Sealing the entire world without delay,
Like an enormous cocoon abhorred.
Oh rain, the seraphic rain!
She came at night to end the bane,
Giving up her transparent body
To a just cause without hesitancy.
She wrapped the sand rampant running,
To the ground, instantly dropping,
Without the slightest misgiving.
It's sunny again the following day,
She's succeeded in keeping the storm at bay.
Out of the cocoon, the world sees another day.
The rain I want to follow to the end,
But she has already turned into a legend.

THE SOUL MAKES A NOBLE FLIGHT

As I stand on the plateau filled with cheer,

I feel my mind suffering no altitude hypoxia.

Like the poplars on the highland,

I reach up to the sky each my hand,

Expressing a desire to touch the firmament.

The sun pours its scalding light on my skin,

It feels as if it were pricked by many a pin.

The scourge comes as a sudden drop of temperature,

Tanning all the exposed parts of my body.

For my admiration, sunburn is the signature.

For now, I can open and close my eyelashes,

Which I consider a tribute I pay to Helios.

But I must make my soul prance like a stallion,

So that it can make a flight of exaltation.

THE SKY WEARING A BLUE QIPAO

The sky is wearing a blue cheongsam

Like a flying Apsaras, proud and free.

She's as pure jade and clean as ice,

Looking down from above chastely.

The clouds are the embedded pattern,

Where the knotted buttons are hidden.

I saw wind trying to unfasten them,

But it apparently didn't know how.

It eventually wrinkled the cheongsam,

Thus, changing the cloud patterns now.

The wind went away, puffing with anger,

Leaving me on the plateau with wonder.

Though my neck aches due to my looking up,

The idea of feasting my eyes I won't give up.

I SEE A CRESCENT MOON NEARING

Looking up, I see a crescent moon slowly nearing,

Apparently, it's a sampan drifting,

Through darkness and wavy clouds cleaving,

The grains on its starboard it's showing

Clearly and brightly glistening.

Now, on the highland, I'm standing,

So close to her that I can touch her,

If my hands I prefer up reaching.

Do you know how many times in my dreams

Has such a scene been happening?

My expectations have grown into poplars soaring.

As I'm contemplating,

She has made a turn, only a poem line leaving

At the corner of my eyes tearing.

A MAGNIFICENT TRILL

That was a magnificent trill,

Coming from no one knows where.

Looking up, I search with my gaze still,

Thinking of it as the only one there.

That's because the sound flies like a fairy,

With her golden wings glistening.

If you don't mind, lend a feather shaft to me,

So that I can wake up the sleeping

Mountain flowers by expressing

Their pent-up feelings

Amid the plateau wind whistling.

I can even bring the world to sing with me.

Oh, the trills of the Pamir eagle flute

Are the most magic wand of nature's symphony.

PLEASE LEND ME THE PLATFORM ON THE PLATEAU

Please lend me the platform on the plateau,

So that I can approach the ocean-like sky.

Please lend me the ancient beacon fire,

So that I can light up the time fleeting by.

Please lend me the calmness of the glacier

So that I can gather my mental power going awry.

Please lend me a branch of the desert poplar

Precisely like a Tajik girl's arm

Both graceful and slender.

I want to angle that crescent moon,

Which looks plump and tender.

I want to invite all the poets like Li Bai,

To an unprecedented and unrepeatable dinner,

Where we'll chant poems that live forever.

022 FENCING IN THE CLOUDS

I thought once I was on the plateau,

My hands over the clouds I could run.

But like relaxed sheep moving slow,

They treat me as grass as if I were no one,

Bringing me some pain and woe,

As they fly above the highland barren.

I want to keep them from drifting,

But only my imagination defies blocking.

The entire day I'm looking up at thee

When suddenly I've grown from a weed,

Into a branch of a towering tree.

I agitated the sky with the wind helping me.

I find the night dropping its curtain lower,

Driving the sheep-like clouds into a pen yonder.

WHO CAN STAY IN THE SKY FOR LONG?

Who can stay in the sky for long?

Is it your kite flying headlong,

Or is it a cloud surging along,

Or a bird singing a song?

They say it's the orb of the night

That can, for the longest, shine bright.

But they may have forgotten

That it disappears entirely by day,

As if, having seen other's privacy at night,

It felt too ashamed to stay.

Watching the sky on the highland,

That tree branch hanging high, I find,

Holding my humbleness over it,

It's been beckoning up there in my mind.

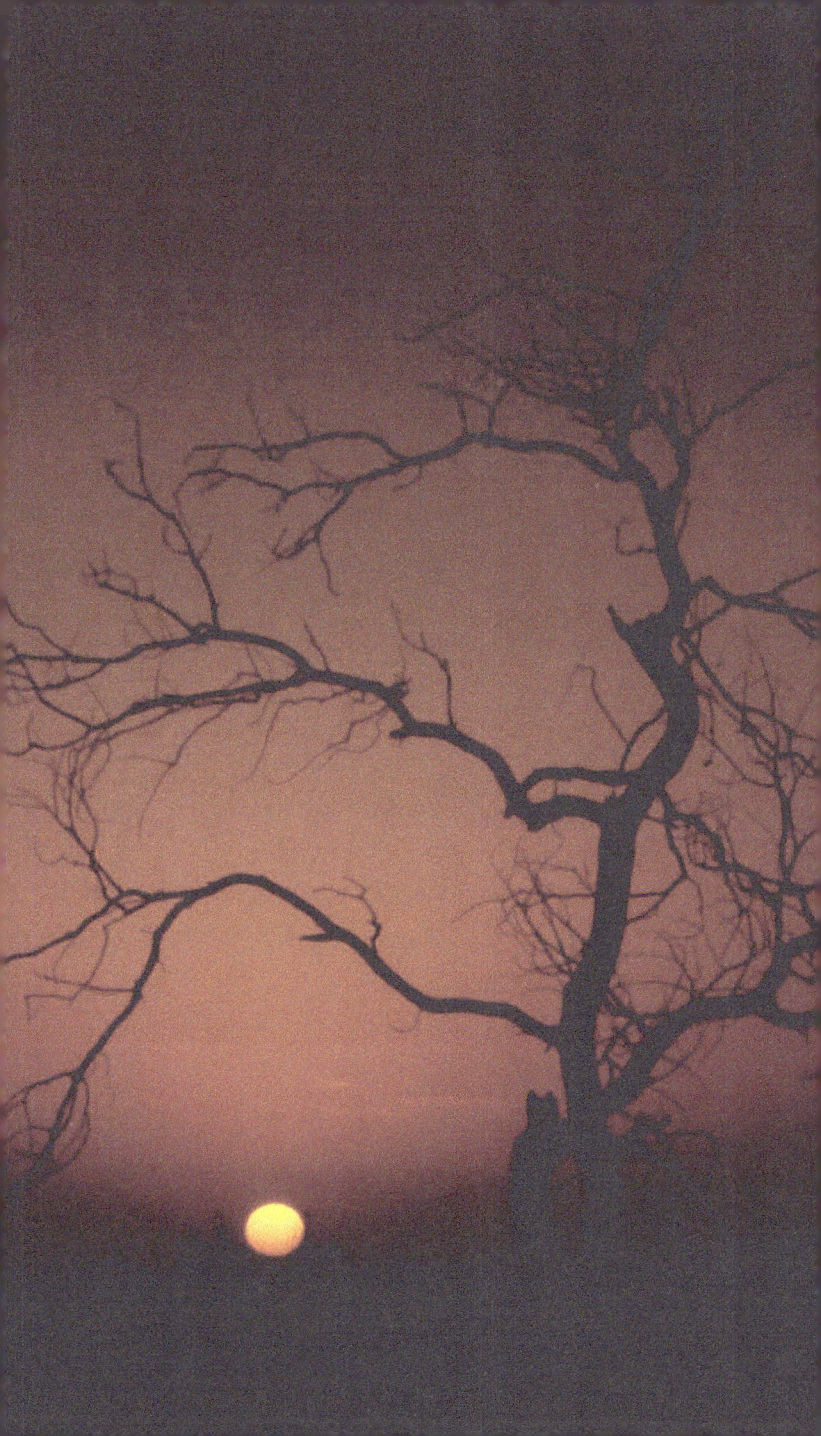

I'VE LEFT MY SOUL AT THE FAR END OF THE PLATEAU

I know for sure:

The plateau is only a temporary moor

That can carry my corporeal body poor.

The physical distance between the sky and me

Is as far apart as tens of thousands of li.

Wind and rain can plunge me to the earth,

While the clouds and rainbows can also

Set off the sky, making it more of a mystery.

After a penetrating gaze at the sky,

I've already left my soul on the land high.

It will set out at any time from there,

Drifting in the air with a heart light.

In the clouds, it will also saunter,

Feeling happy but not the slightest terror.

MUZTAGH ATA'S GLACIER

As broiling as a flame,
Like a burning love affair.
Each tongue of the flame
constantly leaps into the air,
Drawing a line pure and fine.
To heaven, it sings eulogies
And ballads pure and divine.
Its singing moves itself to tears,
Which finally formed the Karakul.
While revealing all its tenderness,
The glistening lake also proves faithful.
Another kind of devotion is its clarity,
Which burns vigorously and steadily.
Oh, the brightest star, watch boldly,
There'll be a sheet of flame eventually
In this snobbish world of humanity,
Still burning with vitality.

026 SNOW FOG ABOVE THE GLACIER

Who issued the clouds billow after billow,
Enabling the tensed-up azure sky
To spill out its long-kept hangup?
Overlooking everything below,
It allows the dazzling sun in the morning
To pester the glacier not to be offended.
Generations of protracted battles then follow.
They're conflicts no one can stop with persuasion:
Even wind has to quit after the failed intervention.
All the time, I've been there standing;
As helpless as the blue sky I'm feeling.
But before my realization,
I find the clouds already risen.
A product of compromise between cold and heat,
They form an aerial garden that nothing can beat.

BOUNDARY MARKER NO. 7

In a world of ice and snow solitary
And in the long years of loneliness,
You've been standing in solemnity,
Vowing to fulfill a sacred mission;
Denying indulgence in amorous amity.
Here the air is as thin as paper.
Patrolling the border back and forth,
There's a brave and faithful soldier,
His cheeks reddened due to the wind north.
They declined the camera flash's flare,
Trying to caress their faces with care,
But accept compatriots' respectful stare.
They gently stroke my hands,
Transmitting their body heat.
And, meanwhile, they feel my heartbeat.
Though guard they're standing,
They're like mountain eagles flying.

THE GLACIER'S COLOR

White doesn't mean cleanliness.

When flowers wither and to dust return,

Their depressing colorlessness

Into a shocking beauty may turn.

One doesn't have to look up at a glacier.

It offers a kinder perspective from above,

When inspected at a distance closer.

That color is as crystal clear

As my eyes' lenses I hold dear.

The jade from the mountaintop may be flawless,

But it can be too frail to retain its pureness.

Only the sediment of life's vicissitudes

Retains its long-lasting nobleness.

Causing crow's feet to appear around my eyes,

Like the grains of the land that before me lies.

AVALANCHES HAPPEN EVERYDAY

There's so much snow

Clinging to the crags.

What's trembling, the snow

Or the mountain fog that sags?

If it were not for the sunrise,

There must have been many misjudged cases.

Already a light medium of flesh and soul,

Embracing the mountains with hands cold.

Oh, snow is also affirming its purity.

But it crumbles with the sun's gentle caress.

As it's disintegrated inwardly already,

All hell will then break loose.

Mountains are not to blame for avalanches.

Unable to grab the hillside,

to the bottom, itself it plunges.

In its fall, a "Bye!" to the world, it utters.

A CITY CLOSEST TO THE SUN

You straddle the lake of shifting sand,

You shoulder a mountain of all-time sorrows.

I see you like an eagle the way you stand,

But you've shed all your plumes,

Though the outline of your flight remains,

As seen in the Sun God's legend grand.

Your walls and embattlement remain as alert

As an eagle, except for a more petrified hush.

The closest to the sun, a city stalwart,

Like the ever-lasting sun, you defy times' crush.

For, genuinely hard are the stones of the chateau,

Forming the backbone of the Pamir Plateau.

Though weathered by the changes of times,

It wants to look handsome and stately.

As seen yesterday, it still stands mighty.

FLYING ALONG THE TIANSHAN MOUNTAINS

The clouds are being coquettish today,

Her hands the range she reaches to touch,

Though barely visible in the foreplay,

Show her infatuation with it very much.

The mountain is quite inebriated today,

It's hanging down its eyelids slightly,

Remaining quiet though having lots to say,

And enjoying an orgasmic moment silently.

I spot the scene flying on an airplane.

To be honest, my act of a peeping Tom,

Arouses a pleasant sensation hard to refrain.

Sometimes, I redirect my eyes elsewhere,

Sitting bolt upright like a gentleman.

I think I can behave more like a man,

But my eyes keep peeping down the plane,

And then I find it difficult to restrain.

BEAUTY OF LOULAN

You're back from a few thousand years,
Not as stark naked as you had been born.
A scar on your brow bridge fresh appears;
You're wrapped in your garment untorn.
You keep your eyes shut as if not to stand
Seeing wars fought with murderous swords
And be distressed by the chaos on this land.
The later generations' gazes of reverence,
Every day, display their renewed brilliance.
As they dance on your muscle and skin,
You may have felt the tickling of a pin.
While trying hard to suppress your laughter,
You've avoided the temptation of the future.

LOP NUR

Shall I salute you as an ordinary person

Or a questioner of you vast and baren?

You've destroyed as many heroes

As you've made them as you chose.

In your chest, you're laying bare,

Many amazing secrets are hidden there.

Shall I wish you to stretch infinitely

Or shrink till not an inch we can see?

Making those missing their loved ones despair,

You also secretly stoke hopes and call it fair.

Oh, Lop Nur, all the way,

The desert poplars urged me to give my utterance,

But I'm just a passing goat,

I can do nothing but watch you from a distance.

MY GOBI DESERT

It doesn't have my name on it,

I didn't even know it the year before last.

Now, I'm no longer a stranger, I admit,

As I can back it up with the proof amassed.

I'm familiar with every blade of its grass,

Every whiff of its fragrance,

And each of its colors

Varying in the four seasons.

When I step closer, inch by inch,

It has no intention to flinch.

When I say away, I'll break,

No complaints he'll make;

For me, he promises to wait.

I come and go in a great hurry,

Getting what I want from it at will:

Original ideas for writing my poetry.

ANOTHER FAMILIAR SPRING

This winter, it seems to me,

Is as long as a man's life can be.

And it's true everywhere in China.

In a city veiled in the black of night,

Tall and graceful trees

Dance in the cold breeze,

Whistling like violins in a fantasy,

A familiar sound airy.

Pardon me,

I don't know if I should

Chant a sad poem or sing a song happy.

I come and go in haste,

Which is everyone's life prosaic.

But the ice-bound land

Cracks into patterns mosaic,

As brightly colorful as in a dreamland.

It's a spring arriving earlier,

Hijacking me unstoppably,

And rushing me to the heat of summer.

REEDS

They stand in the water,

In a comfortable posture.

Bosten Lake lies quiet,

With a broad mind

But not a single breaker.

They bow to the wind,

Shaking their fluffy heads white.

They spring back upright,

To stretch with a smile bright.

Erect, clean, warm, and slender,

Each stem is a line of a poem,

Filtered by spring's splendor.

Though no beauties are strolling,

Graceful little egrets and water lilies

Are now hidden and now appearing.

The scene is a world far from mundane.

Cut down by people this autumn,

The next spring, they'll return lush again.

THE RAIN IN MY HOMETOWN LAST NIGHT

The rain in my hometown falling

Soaked my dream last night.

It blanched in the dark everything.

It was already broad daylight

when I went out this morning.

High above shedding its light,

The moon over Kashi is lingering.

Has it traveled the entire night,

from my hometown, rushing?

Its face shines with a hue of twilight.

Like the moon, mine is pale turning,

Resulting from my sorrowful plight.

From a distance, at me it's gazing,

Daring not touch my loneliness with its light.

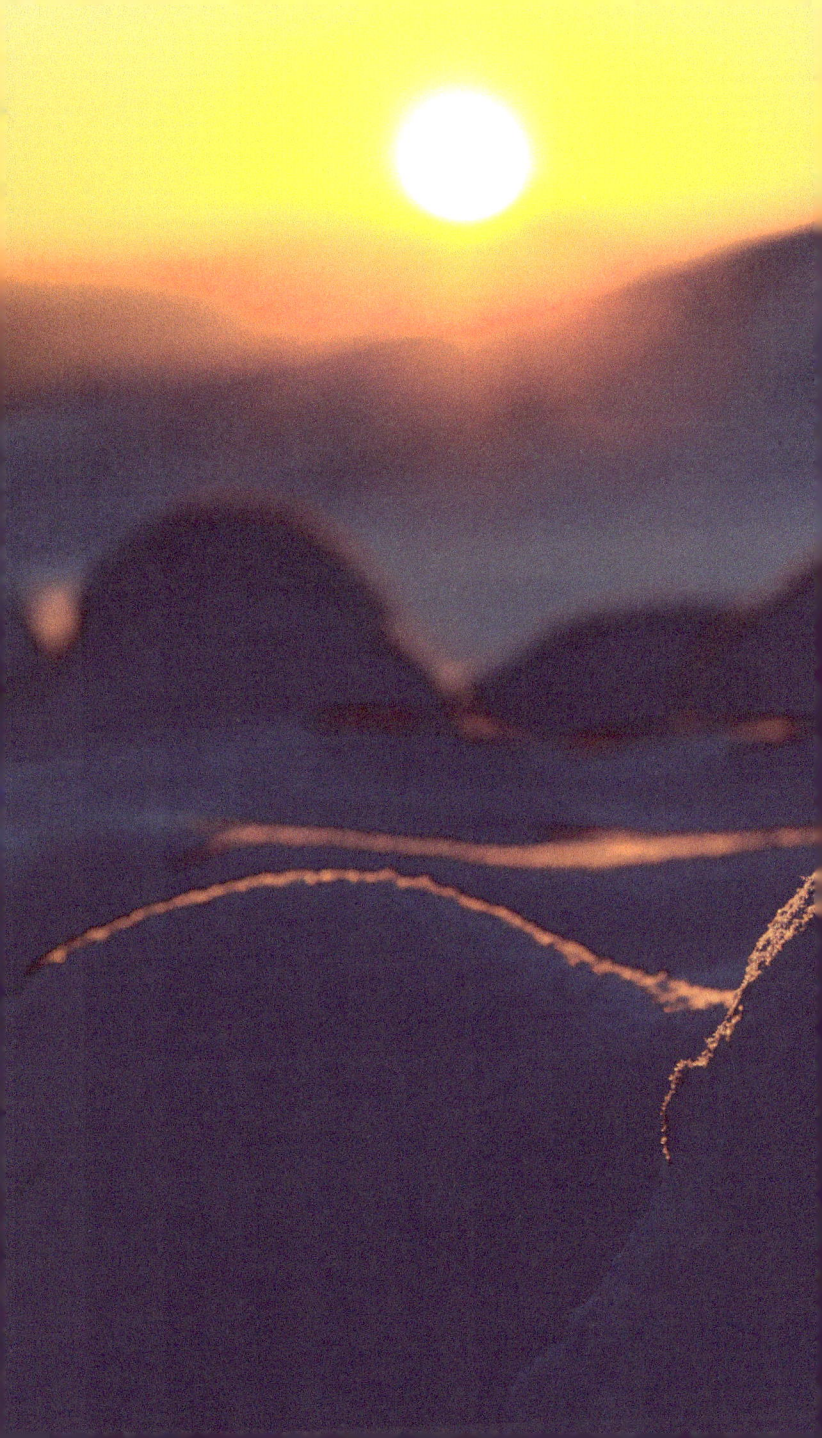

SILENCE IS THE DEPOSITION OF A DAY

This silence is the deposition of a day,

Restlessness replaced by quietude.

At the intersection of time I stay,

Over the past and the future, I brood.

I must be honest with you as this I say:

I'm very fond of this moment of serenity.

Because deep silence prevails over all,

I hear but verses whispering quietly.

How much is left of the enduring power

In the things that raise a riotous clamor?

But it can't break through the nighttide.

Everything that we can find in the world

Has always been incredible when unfurled.

AUTUMN MOON

Who's created the fall Moon Kashi pacing,
With a pair of hands pure and affectionate,
Because it's so cool and refreshing,
And remarkably mellow and immaculate?
As if it had been laundered for ages
By the tenderness of a man of south China,
The influence of Li Bai's poetry by stages,
And the drastic changes in time as a drama.
Now you've acquired such pride and confidence.
I'll use the snow from the Muztagh Ata,
To wash away the worries in my conscience.
I'll ride the crescent harvest Moon,
Taking a mental journey on the Silk Road long,
To pick up the manliness left by Xuanzang.

THE LAMBSKIN HAT

It's smooth, glossy,

Dark-purple, and fine-grained.

Here's a mother happy.

She puts it on her son's head,

Breaking into a smile in the shade sunny.

There's Mother in another place,

It's yearning for her weak baby,

Pining and crying hopelessly.

If it had its choice,

It would put the baby back in her belly.

As soon as it was born,

With it, people want their heads to adorn.

What can I say?

I have to nip off the tears blurring my eyes,

As if an umbilical cord to cut away,

And bid goodbye forever

To a kind of kindness today.

A MINE'S LANGUAGE

Mines are here and there scattering.

The sun sees the mountains glistening.

Prospectors produce clouds of smoke,

As if a fire they were extinguishing.

The mist curls like butterflies fluttering.

A little gold shows up now and then.

But copper, silver, aluminum, and iron,

Each claim to be the primary denizen,

Giving gold no chance to say anything.

In this manner, many mountains are behaving,

Enchanting people with their blushes.

Beneath the crags their innocence burying,

Who can excavate the scripture mystifying?

The case applies to a language's phonemes,

Which can only reveal their true colors

In the melting pot of time, it seems.

A PRIVATE CONVERSATION IN AUTUMN

The fingers of this season

Are as slender as the branches of willows;

The notes they strike are like fallen leaves,

Drifting throughout the streets with sorrows.

The clouds are also aloof and lonely,

A deep sigh heaving

In the time unable to stop elapsing.

They spread all over the sky

Because the hometown is pining.

Now, my heart is also drifting.

Even in this Gobi desert barren,

One can find young branches growing,

Slowly, slowly budding.

On an empty street, I am walking

When my eyes meet those of a cloud,

And I find them familiar and proud.

Like two singers, in harmony we sing.

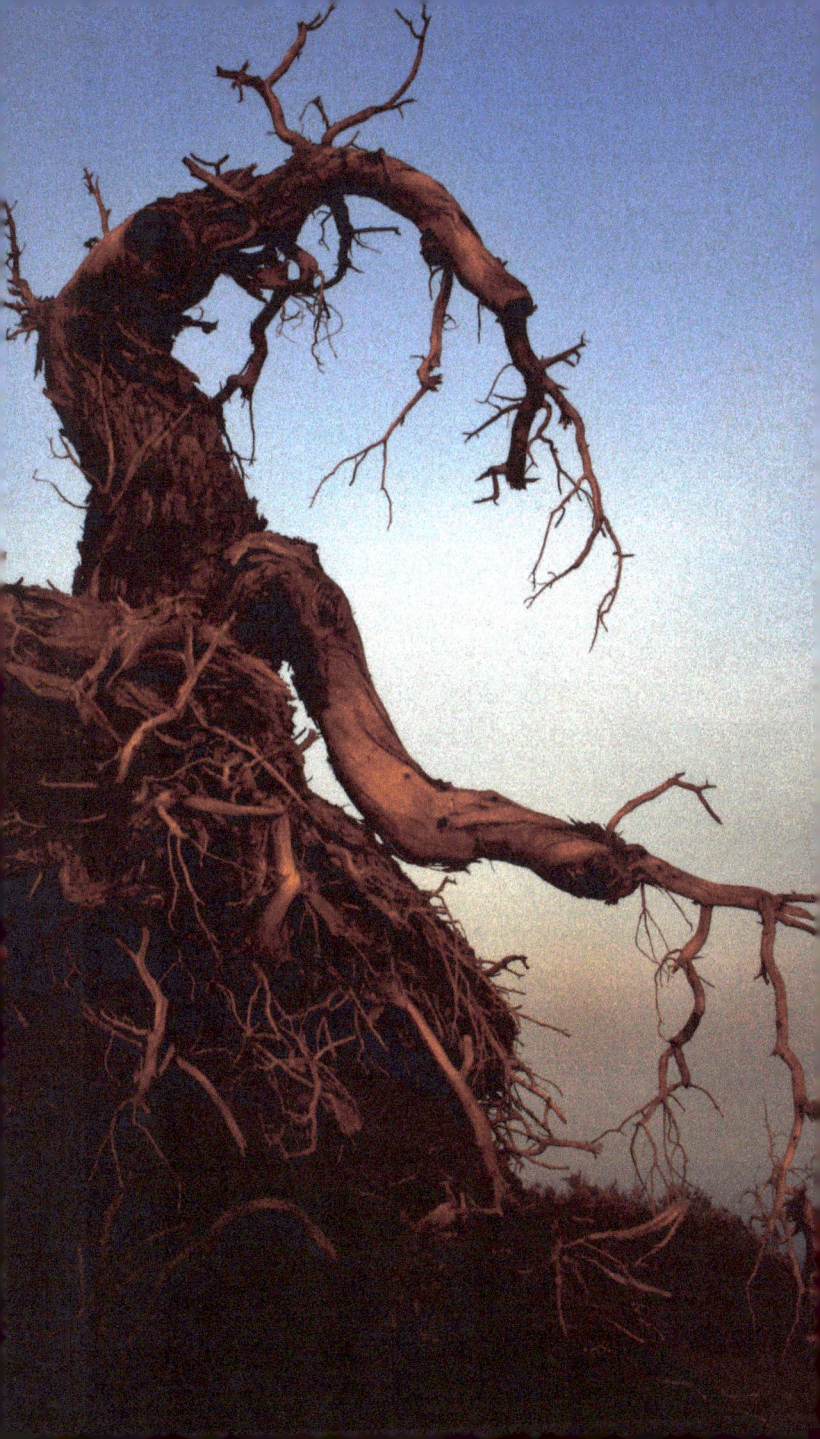

A WIND ROSE

A wind rose in Kashi this evening.

The leaves were gently singing;

The sand was joyously dancing.

The judgment of me, a southern man

Predicted a shower of lovesickness,

Floating in the air with tenderness.

I looked up agape with chapped lips,

Waiting for long-expected ebullience.

The wind blew with increased velocity,

Tapping my doors and windows frequently.

As I stepped out to greet the blast,

I hear a white-haired man bellowing:

"Rain vanishes as soon as the wind is rising!"

I froze for a long time, and as it were,

Struck dumb as a wooden sculpture.

THE TIANSHAN GRAND CANYON

I wonder how many thousand years of purity
Have gone into forming such a limpid lake?
Though it's gotten its name from swans bonny,
Swans hate spoiling its jasper-like water.
Some horses, undistinguished for appearance,
Roam and graze like a few patches of clouds
Between the sky and the land of luxuriance.
An old mare recounts a life of happiness,
While she's gazing at her shadow in the lake,
Seeming to be a petrified figure of the past.
A frisking pony gallops into the distance.
I don't have any idea about their former lives
Neither do I know of their generic inheritance.
But I know: I'm no better than their existence.

MUDSLIDE'S AFFECTION

He comes from the acme,
Sometimes passionate, and
Sometimes tender infinitely.
The eloping mud and water are deep in love,
And their love-making is earth-shaking,
Breaching the bottom line of morality.
They moan when they are in close contact,
But they keep screaming most of the time.
Treating each other gently,
Mud and water are frolicky.
Rubbing the hillsides into pine-like crags
Soaring into the sky precipitously.
Who wouldn't admire this scene of love?
Mudslides are sentimental poets innately.
Sometimes, I'd give him some advice secretly,
But I fear if I say too much,
He would behave like a ninny.

A SANDSTORM COMES GRACEFULLY

"Graceful" is a perfect modifier.

And with this beautiful adjective.

They drift over altogether,

Dimming the midday sun sportive.

Then, they blot out, in silence,

The buildings that stand naive.

Then, one by one, the trees

Cease to be imaginative.

There lies a vast sea

About ten meters away.

Then, it weaves things into dusk,

Which, like a magic stage,

Expecting to debut an excellent play.

Knowing nothing about sandstorms,

I gaze in a stupor.

Then, a sand grain dominates my eyes

Forcing out many a teary flower.

A YULAN MAGNOLIA IN THE COURTYARD

I listen to her humming a tune from Jiangnan,
Which expresses her subtle distress wordless.
Her pistils heavy with a craving for love,
Her leaf veins are burning with lovesickness.
How did she end up here, and does she have
Someone faraway for whom she cares?
The hands of the sandstorms in the north
Are extremely rough for all their tenderness.
But this woman coming from China southern,
Can she forget the southerly rain's affection?
Knowing none can take her away, for sure.
I only want to say a few more words to her.
In my soft Wu dialect, I'll gently murmur,
From my homesick eyes, tears brim over.

A TREE

Even when role models fall down
Like the petals of flowers,
You and I are still standing,
We live our lives upright and dignified.
When depressed, I may glance up a bit,
The capricious rain and wind teasing,
Trying to dampen our dreams of flying.
But they make us composed and sound.
We wave to feign dullness though wise,
While we root our feet in the ground.
Even if cast in the endless desert,
We still appear pensive in all our glory.
It takes a lifetime to learn to be a tree
And become an altar lamp
To light up fragrant foliage eternally.

A SANDSTORM BLOWS TO MY HOMETOWN

A sandstorm has blown into my hometown,
Under my feet here, quaking the ground.
As it runs faster than my legs carry me,
I can only try to stop it with homesickness.
Moderate pollution by the sandy fiends
Is quite a disaster plaguing a metropolis,
Where I have my relatives and friends.
How long will the sandstorm's craze go on?
I wish I could clasp the storm in my hands,
Like a legendary hero subduing a dragon.
I also wish that it would swirl around me,
Heaping into a gable wall concrete.
I wish it wouldn't show off in my birthplace!
Nor would it in the north here leisurely pace.

A PEBBLE

From the White Jade River,

I picked up a pebble.

Fist-sized, it could be used as a grenade.

Its fine grains resembled clouds graceful.

Most people were scornful:

"Why do you keep something available everywhere?"

"So, you'll succumb to the herd mentality?"

I glimpsed the stone grinning at me slyly.

Holding it, I felt we shared a kindred spirit.

Because I loathed to part with it,

It has since become part of urban life.

Basking in the caring sun on my desk,

Its fate has since taken a sharp turn:

It has to part company with white jade.

AUTUMN ON THE NALATI GRASSLAND (TWO POEMS)

1. Verses Glisten on Grass Tips

Verses are on the tips of the grass shiny,

Flutter on the summit of mountains snowy,

Burst forth with galloping horses' clops,

Scenting the air with sheep's grass chewy.

The azure sky cast its reading eyes,

Deeply intoxicated by each poetic line.

Imbibing it, the pupils of the eyes

As clearly and spotlessly shine.

The meadow's countless hands lively,

Never grudge their silent claps,

To acclaim the untainted poetry.

Autumn on the Nalati Grassland

Paces as slowly as the sheep and cattle.

It's but a whiff of a rhythmic line,

Where life's golden achievements settle.

2. The Emptiness of Autumn Days

Even on such sunlit grassland,

There's a moment of persistent autumn chill.

The beautiful soul of Princess Xijun

Is back to her hometown like a bird of free will,

The sorrowful verses, however,

Are still trying to greet her on the prairie.

Her eternal homesickness on this strange land

Is alleviated by the princess' prosperity.

Isn't the overgrowth meeting the eye on every side

Her confused yearning for her homeland?

I want to break the silence of the pasture

By crooning, but my murmur

Did nothing but increase

The autumn days' emptiness.

ON THE EMPTY STAGE

On the empty stage,

Desert poplars are natural performers.

They sing solo and suites of songs,

They're primarily melodious andantes.

Camelthorns and salt cedars

Form overlayed accompaniment,

Condensed and in rondo form.

Wind and sand always come together,

Sometimes, they come to cheer

With their chorus coming and going.

Sometimes, they're troublemakers,

As uncouth, pestering children do.

When the sun joins the concert like a piano,

With the momentum of a sea of breakers,

Everything returns to a chord aglow.

A SANDSTORM IS AN URCHIN RUNNING WILD

A sandstorm is an urchin running wild,
He's in the habit of roaming around.
To the wind's unruly call responding,
He takes to flight at dizzying speed,
And run around frisking and gamboling.
Neither salt cedars nor desert poplars
Find it hard to get him under control.
Only the whip of a highway's lashing
Or the reeds' crushing wrap around him
Can calm him down, forcing him to return.
His dream is to fill the sky while flying.
Thanks to the mountain's tenderness,
He can finally snuggle into its arms,
With his silvery eyes brightly shining.

VARIOUS KINDS OF STRANGE FORMS

Various kinds of strange forms,

Must have stemmed from strange thoughts.

Can a proponent of a philosophy

Perceive the sky more deeply

Than if he stands in the desert Gobi

On the ground of a big city?

Eve's like a Buddhist dream coming true,

With stars twinkling brightly,

Rendering vivid verses into broken walls.

As the moon casts its net in secrecy,

I find that freedom can be so balmy.

Loneliness chilled to the bone

Can be the paradise for a wise man.

Desert poplars hating to leave the Gobi

Are invisible scholars of the pre-Qin era,

Who are flying in the air freely.

SILENCE IS REAL GOLD'S SENSE OF LOSS

The vaster the land exends,

The less colorful it'll be.

Sheep and cattle can't jump out of it,

And its color is as grey as the sky cloudy.

We can't even find in it

a flea that eats lice nasty.

Who can bear such loneliness and boredom?

Sand and dust are flying about,

In soft and graceful lines dancing,

the endless dikes resembling

To resist the dullness harassing.

Unrestraint doesn't mean iniquity.

Even individual grains of sand and dust

Want to be torrentially wavy.

This is the age of dancing, alas!

Silence is real gold's sense of loss.

056 THE AMOUNT OF SAND IS THE WORD COUNT

The vast desert's grains of sand

Amount to the word count in a tome gigantic.

Through efforts akin to self-mutilation,

They were drafted in times remotely antique.

Each word glistens

Like gold or silver.

Each chapter flipped through by the wind

Is free from being worldly and vulgar.

Like myriad arrow heads, words fraying

Have failed to obstruct

The lofty sentiments of millions of years.

Akin to the sun's whiskers, words fawning

Can't shake the condensed way of writing.

Some people came and went. Even Cangjie, creator

Of Chinese characters, fails to recognize them.

They constitute the sutras of the Earth Mother.

Like a crawly bug,

I'm boring and reading the book whopper.

ALL THE CLOUDS FELL SCATTERED ONTO THE GROUND

When did the clouds that fill the sky

Fall scattered onto the ground?

No matter how hard they try,

They can't resume their original way to fly.

Their snaking waist

And their confused dancing shadows

Interpret in vain their wild wishes to fly.

I also want to come out of yesterday

Imagining to fall from the sky.

Without being cold, sad, or scared,

On the ground, I lie,

And become a grain of sand,

Now smiling, now lamenting.

Even a single line of an abstruse verse

Represents my sublime thinking.

The sand and dust chasing each other

Show my childlike innocence's flourishing.

LIGHTING UP THE DESERT WITH THEIR SONGS

It's not that the sun sinks into the desert,

It's the sun that collects the sand and the sky.

In the sun's last look so sly

There's a chilly voice, shining and jumping,

Till it becomes stars filling the sky

And crowding my car windows.

At the grey dawn of the day following,

The sun slowly spews endless desolation.

Something extremely unusual

Has happened in this rinsed agony.

A few crows, in an unconventional way,

Lights up the desert with their melody.

I DON'T MEAN NOT TO CROSS THIS DEAD SILENCE

I don't mean not to cross this dead silence.

It's that I fear my footfalls would awaken

The sand and dust from sleeping quiescence.

They would then completely surround me,

Retaining me with boundless hospitality.

Then, my poetry would be kept from flying

And condensed into a sandstorm ravaging.

THE AGING OF THE DESERT

What would happen

When the desert aged?

Would plants dance merrily?

Would an ocean sing heartily?

If the earth got senile,

Would desert cover it all?

At the speculation, I shudder,

As if startled from a dream.

Not a word of surprise I utter.

THE SECRET OF REMOTE ANTIQUITY

That secret of remote antiquity,

Buried in the desert deeply.

What gust of bored sandstorm of modernity

Lifts the robe of the Miran site

And invites bees to swarm

And collect the magic soul uptight?

Even if naked and robust,

It wouldn't weaken in the sun,

Burning its built-up underground energy.

Come on, you! Hold out your hand greedy

And let it shiver in the cold voluntarily.

Now that it recognizes its folly,

The sandstorm writes a raged apology

To defend itself and pray for that secrecy.

WHEN SAND AND DUST GATHER INTO A STORM

When sand and dust into a storm gather,

I always shut my engine down,

As a ritual of showing respect to a senior.

I remain reticent, and even infrequent visits

If there are any, are never cut short.

This antique-like old man

Has too many stories to exhort

His future generations to remember.

But he's gotten an idiosyncratic temper,

Which, when expressed, may not be melodious

And may startle many a curious listener.

I may as well be an obedient youngster,

Cuddling in the deep wrinkles of his face,

To watch him indulging his ill humor

And listen to him moan later.

THE STARS AT NIGHT

The stars twinkling in the night

Always overlook the desert from their height.

Their unconcealable gaze of disdain

Betrays a sneer hard to explain.

Their separated, lonely bodies

Have no idea that once dimmed

They're nothing but many a soil grain.

Who would then look up at them in vain?

Instead, the sand's show its intimacy

Would evoke imagination cozy.

I HAVEN'T HIKED SO FAR

I haven't hiked so far. I mean
I haven't stepped into the sand.
She's a mysterious, captivating beauty.
Who knows how many
Lovers she has? They can lurk anywhere.
I feel drawn to her due to her being flirty.
But I also fear I might return a zombie.
Both cases would be fascinating legends.
I've got a hero named Yu from my city.
Full of the dash, he's been in the sand frequently,
Eventually, going up into smoke on the sand.
I'm sorry, but I choose to be a chicken:
I can gaze at the desert from a distance only
Like the Kunlun Mountains to incur no agony.

065 I STILL FEEL THE SORROWS OF METROPOLISES

I still feel the sorrows of a metropolis,

Feeling a bit content with my achievements.

Seeing you, I'm panicked and speechless,

Like a grain of sand swept up by high wind.

You've plunged me deep into absolute silence;

I can't bear to retrospect the past splendidness.

The desert's vital energy

Is the vitamin we need badly,

Allowing me to stand upright.

Those who have ventured into the desert

Have since become as invincible

As the souls of the heroes admirable.

How proud they are of having in hand

The record of being close to the sand.

IT'S SAID TO BE THE SITE OF AN ANCIENT CITY

It's said to be the site of an ancient city,
But I found a coin brighter than that of Tang's.
Everyone gazed down at it simultaneously,
With wild wishes to use it as a fuse to ignite
Something splendid, all wish to have eagle eyes,
Aided by the infrared's power of time travel.
Their gazes digging deep into the ground,
They seem to press their lips on the face smiling.
Hurried excavation linked the present to the past,
In people, an unspeakable desire evoking.
The sun set, slowly shedding its color,
As the candlelight at heart is also fading.
Only the imagination of the ancient beauty
Can create a desert wonder of modernity.

067 IF THERE WERE NO WIND AS MAKEUP

If there were no wind as makeup,

The desert's original face would show.

In the brilliant sunlight at close-up,

The details of its dense pores glow.

But from her countenance easeful,

You can detect deep in her heart

If she's tranquil or unpeaceful.

WHAT'S THE MEANING OF LIFE IF WE WALK LIKE THIS?

What's the meaning of life if we walk this way?

When can we reach our destination the way we do?

Traveling with a camel companion all the way,

I confide to the camel

Everything in the recess of my heart.

But as a lower animal,

It assumes a nonchalant attitude

Toward the questions from a higher animal.

It keeps trudging along,

As if all his answers are under its feet.

Casting the sun's shadow elongate,

Upon my entire body animate.

069 WHAT'S BEHIND THIS DESERT?

"What's behind this desert?"

People ask for an answer.

"It's another desert!"

Was Sanmao's response

Before her departure.

But you are convinced:

There must be an oasis,

Where there's a community center

A life of comfort to offer.

The desertified hands,

May touch your head and face, but

It'll take away your homesickness never.

SNOWFLAKES IN 2008

Snowflakes fell suddenly
On the Taklamakan Desert in 2008.
Most of the bodies heavenly
Are said to be desert lightweight.
So, I guess that snowflakes
Must be extraterrestrial emissaries.
It's a counterpart desert's a handshake.
But most regard this speculation as naive,
Seeing through the adult's intent.
A surge of panic hits, followed by
An unprecedentedly grand mass dating event,
With a waltz of youth, graceful and melodic.
Then, each departs with its love and content,
Silence reigns for the time being,
Making people blush with hearts throbbing.

IN AN AFFECTIONATE MANNER

Walking in a gait mincing,

In the torrid sun and on the arid sand.

Looking up, I see the lakeshore refreshing.

I walk closer and closer

In an affectionate manner,

To greet the water's transparent glitter.

What a sandstorm has exposed

Is still the desert hither and thither.

What I see is but a fleeting mirage,

Like a dream evaporating.

Hotter waves come surging,

It roasts the urban souls,

On the cyclone lingering.

IT'S A BOUNDLESS SCENE OF FIRE

It's a scene of fire without end;

The sunset flame looks so golden.

Gradually losing its brilliancy,

It shines like the moon misty.

When to the sky the sun returns,

Ash, instead of passion, remains.

EVEN ON THE VAST DESERT

A small clump of grass

Has a hard time being a speaker

Even on the vast desert,

Because the sand is the dictator.

Stay far away you'd better.

Some may shout themselves hoarse,

But their voice is paltry.

In fact, the world is still magnanimous:

Even in the cement forest of a metropolis,

One can find a nutshell of a house,

A word or two to release.

THE HIGHWAY IS TOO LONG A PAINTING SCROLL

The highway is too long a scroll painting,

Like movie frames changing constantly,

Or like a waterfall dropping smoothly.

As the sky is too distant from the earth,

Everything up there looks fuzzy.

The wind is called for to investigate,

And it asks the sandstorm for assistance.

The sand reproduces the picture repeatedly,

And the wind submits the report to Providence,

Who unfolds the moon and all the stars,

Studying them throughout the night.

But it still fails to discover whether

Taoist tricks or magic are at work.

It keeps searching for an answer,

Sometimes seeming to understand

Sometimes seething with anger.

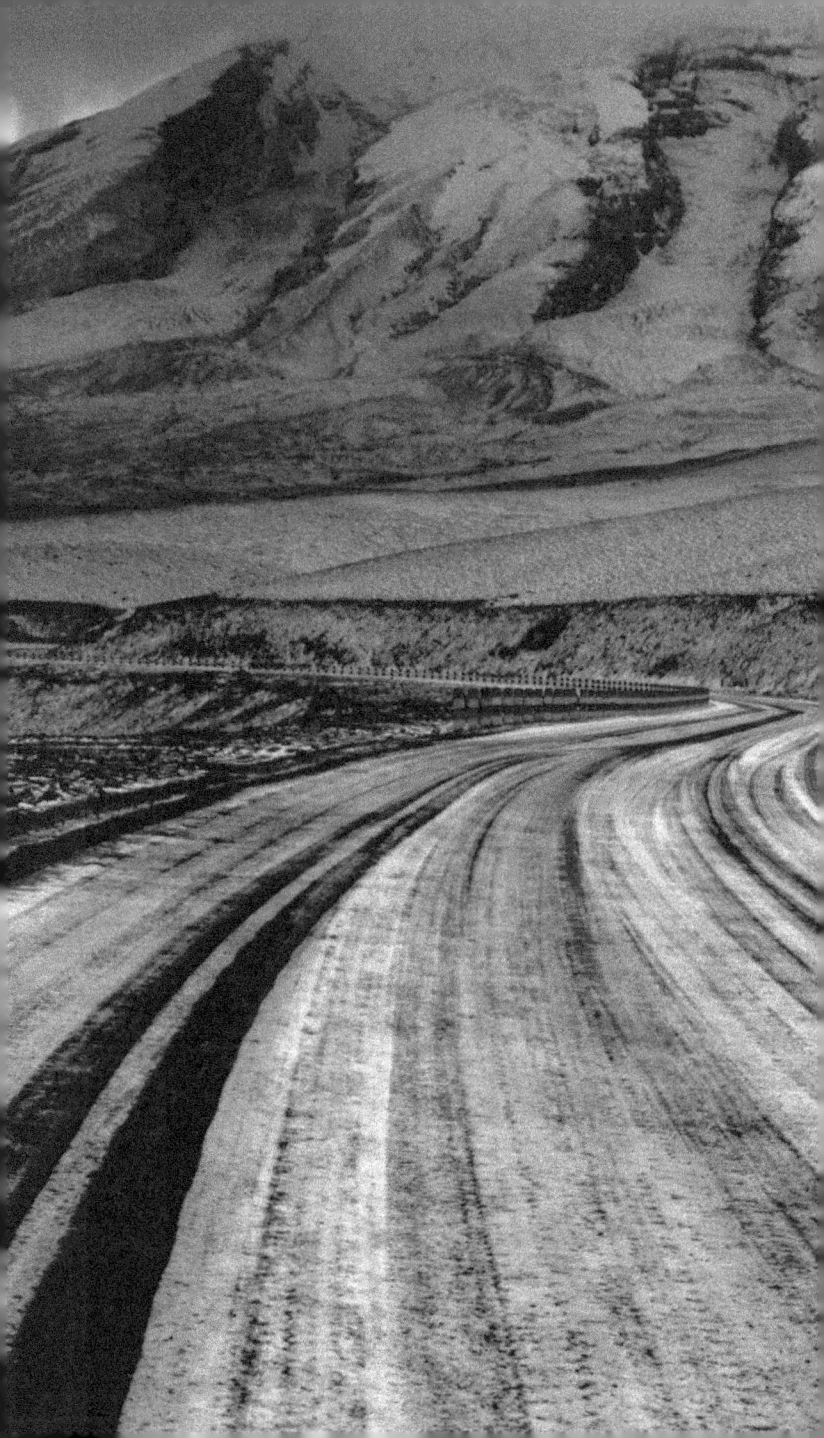

MAZARS ARE LIKE OFFERINGS ARRANGED ORDERLY

Mazars are like offerings arranged orderly,

Ever-increasing on the edge of the desert.

Cawing above them are crows melancholy,

Sweeping up all the sadness and agony,

With their wings fluttering vociferously.

A few desert poplars stand with solemnity,

As they're paying their homage as well

To the time gone by and the past soon to be.

The desert highway, a giant musical instrument

Produces tunes both pleasant and mournful.

The songs of separations and reunions

Constitute a movement of an ancient symphony.

Having been performed for a long time,

The music is still circling the marzas,

Which are the world's largest cemetery.

A SADDLEBAG THAT BELONGS TO THE MODERN ERA

A plastic saddlebag absolutely

Belongs to the era of modernity,

Hanging from that Euphrates poplar,

Between ancient deserts and the Gobi.

It's hard to tell whether it is

A display of anxiety or a cry of modernity.

The sandstorm pumped its wings up;

The sun gives it a glimmer of fantasy.

No one has gone up to send it back

Or scribble on it some graffiti.

To make it ever last with self-confidence,

Here I come being artsy

With words of time travel only,

I lift the bridal veil to show

The fair-complexioned face of a beauty.

A PIOUS KISS

How can I face the desert?
He's like a stalwart old man,
With grey hair and beard.
But he's still magically animated.
I've grown up in a favorable environment.
A little saline-alkali and some cracks
Would make my life extremely miserable.
Oh, the weather-beaten place here
Is showing all the hardships it has suffered,
Sand licking its scars millions of times.
I can only lie prone on its chest cozy,
Giving the feeble camelthorn
My kiss of piety.

A MILLENNIUM OF SILENCE

The wind has sent me to the desert.
Can a vast wasteland entertain
A man from South China? He's just
Learned about Ccamelthorn's toughness
And desert poplar trees' tenaciousness.
Elegant salt cedar also amazes him.
He wishes that all his earnestness
Would turn into a crystal stream
To expedite the birth of a tiny oasis.
The desert enjoys a millennium of silence.
Like an old abbot deep in meditation,
It treats me like a falling dust grain,
Not showing his facial expression.

THE DESERT AND THE MOUNTAINS

The desert and the mountain here
share the same complexion and soul.
In my eyes tainted by landscape beautiful,
The desert is a mountain lying down,
As the mountain is the desert vertical.
Rain is a friend that alienates them,
While wind and sand are their guests willful.
While lacking decorating adornments.
They exhibit masculinity and vigor.
Sweeping up a cloud of sand and dust,
The wind is crooning in a whisper.

080. SHARING THE CHARACTERISTICS OF THE DESERT

When we ventured deep into the desert,

Someone gave me a beautiful *doppa* hat.

However, I declined his caring gesture,

As I share the desert's typical feature.

I didn't want to conceal a reason

For befriending the desert as a cousin.

I allowed the same wind and sand

To blow at my forehead of the same color.

I also let the sunlight pale yellow

Caress my exposed skin of the same glow.

Even on barren land, each desert poplar

Is still waving in the lineup arbor.

CAMELTHORN IS THE DESERT'S TEARS

A tuft after a tuft, they glimmer,

A clump after a clump, they glitter.

You evoke sympathy

But defy human touch.

Your eyelashes limpsy

Stubbornly defend some stubborn pride.

In the barren Gobi desert solitary,

You appear as simple and unadorned

As the water of mountain streams groggy:

When you're unattractive

Due to becoming murky,

You still tumble intermittently.

Crying, what're you trying to tell the world?

The Gobi has done all in its capacity

To converge into this silent mark.

I'm touched profoundly,

As a man replete with water.

Throwing a glance at a distance enormous,

I wish I could with my torrential tears

Create a whistling world of splendidness.

SHIFTING SAND

Shifting sand, I did know

A long, long time ago.

"It's covered many an oasis,"

Me the desert has just told.

Led on by the wind,

It sprang up at me,

Brandishing its claws flippantly.

I hid in my car,

As it danced like a bacchanal

On the windows of my vehicle.

This earth's restless ego

Now found its stronghold in my auto.

Unwilling to be left out in the cold,

It fluttered its wings uncontrolled.

I wanted to bring up the southern rain,

With all her tenderness and warmth,

To help its usual composure regain.

A HIGHWAY IN THE DESERT

This rope belt wiry

Fastens the desert's dress tightly,

Trying to prevent her from going crazy.

Many times, does she try to break free.

But she starts her struggle as quickly

As she quits, akin to a brief sensation

Caused by a hair lock brushing her earlobe.

I play a piece of music with my fingers,

And the vehicles joyously speeding

Sing to it along their way, kicking up

Gusts of sandstorm swirling,

Elegantly and uncontrollably,

Like a dancer accompanying.

Oh, this rope belt otherworldly,

In its coils surges

The desert's hidden symphony.

STANDING ON THE EDGE OF A DESERT

Standing on the edge of a desert,

Emersed in this sea of remote antiquity,

I find the sun to be lapping waves,

And the sand moss creeping all over me.

Lasting blue washes the sky's nightmare away.

Many living things are running wild and fiery.

I find, in the blink of an eye,

The sea appears haggard abruptly.

How much stabilizing force does it take

To prevent all hell from breaking loose?

I must highly value this experience

Of getting close to this barren land.

I find my interest waning in my heart,

Since miracles can't grow in the sand.

085 I'LL BORROW A DAY'S SNOW FROM NORTH CHINA

Nothing from others have I borrowed,

But I'll ask North China for a favor today.

I request that they lend me a day's snow,

Which take with me to South China I may.

As the snow hasn't fallen there for eons,

I'm afraid the land will forget its purity,

Children can't be happy on each wintry day,

And I'll be estranged from snow heavy.

When it threw in a kiss on my lips one day,

I'd turn aside from it feeling panicky.

Now I'm feeling more uneasy

About my hometown folks in the south,

Because they've got so accustomed

To the prospect of seeing no snowy day.

"If you return timely, you'll borrow more easily,"

As a Chinese sayings go.

So, when a severe drought hits you again,

With my hometown rain, you promise to repay.

I MISS THE SEA WHERE IT'S THE FARTHEST FROM IT

There're mountains and deserts

In a place farthest from the sea,

Which isn't the end of the world,

Where the water surface is bumpy.

My longing resembles camelthorns messy,

Which multiply in all seasons endlessly.

Kneeling in the Gobi desert cowardly,

That light green is none other than me,

Permeated by blood, sweat, and tears.

I don't envy those living by the sea,

A coastal embankment nor do I wish to be.

The sand in the wind is ankle-deep already.

Even if as lead my imagination is as heavy,

I must rendezvous with the rhythmic waves

By crossing a thousand-kilometer territory.

My hometown expects the return of its folks,

As if to yearn for meteorite showers earnestly.

Now, I am in the Gobi desert

That has gone through a great many changes:

It used to be a vast expanse of sea.

I seem to have treasured for billions of years

What the sea has left and bequeathed to me.

BEING BRIEFLY DISTRACTED

Grabbing a glitter from a brook gurgling,
And fishing a whistle from a desert wind,
I produce warmth from a nightmare lingering
And walk more orderly in a marching file.
Poetry is when I'm briefly distracted daily.
Neither expects to trace this habit's origin,
Nor can you date its progress accurately.
Please don't disturb the Muse visiting
And the brief kiss she's bestowing me.
I'll spread the scent like snowflakes,
The air-polluting dust and sand settling.

THE CHARACTER OF A MAN OF VIRTUE

A virtuous man had stood the test of mockery;

A virtuous man was sublimated by extreme misery.

Between honor and disgrace; life and death,

A virtuous man sought the character of humanity.

Smelt and tempered in water repeatedly,

He made the sun regard him as his idol,

As soon as he stepped out of his swaddle.

Behind the man, a snow peak has formed

And for a millennium remained unmelted.

Though aloof and lonely, it's standing,

It cherishes a character awe-inspiring.

PASSING BY A TREE

She's standing where she is,

No wind makes her dance with ease.

I pass by, taking a path as I please.

Snow drapes over her in the Gobi,

Of fair complexion reminding me.

Without a word, She's shaken off,

To the ground, lots of loneliness.

The entire world is silent,

And she's even more reticent.

My heart beats faster,

Being in her company fragrant.

Whose song can arouse our imagination

In this wintry season?

My pace I'm slackening,

And I look back, only to see her

Into a faint smile breaking

In the perfect breeze.

THE SOUND OF CRACKING ICE

Cracking is unique to the north,

But ice blocks always melt

Quietly and shyly in the south.

Loud rumblings are indicative

Of thunder passing under the ice,

Leaping to a distant place.

Now, I'm sure that cracking ice

Is vernal thunder's harbinger,

And sprays are flowers' forerunner.

The footsteps of spring's coming

Are the rhythms of ice breaking.

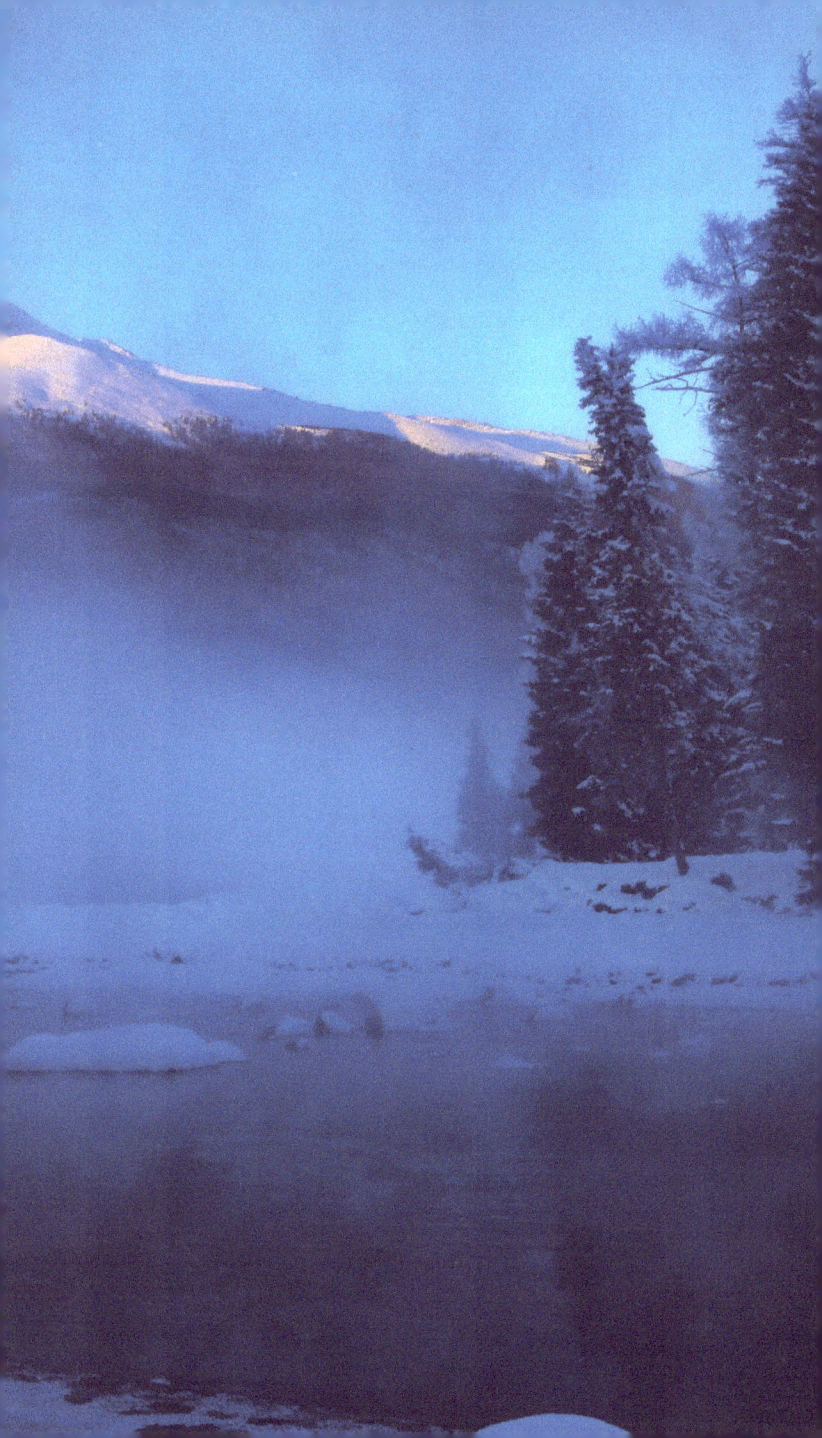

MILLENNIAL TREES IN THE TIANSHAN MOUNTAINS

Who's so omnipotent

As to turn all my dreams

Into concrete images at this instant?

My unlimited fantasies

Sojourned a second, sometimes,

In my consciousness;

And became wild wishes, sometimes:

Such as transforming into a python

All parts of the world to traverse.

I also cherished an eternal yearning

For running amok underground

Before a life of vicissitudes living.

The long-tempered soul of poetry

Is the ever-lasting lightning

And the sail against the wind gusty.

When winter wakes up,

The sheet of white spotlessly

Is still mulling over

Another dream illusory.

THE BACHU COUNTY FOSSIL GULLY

The end of life is nothing but like this:

Bones of fish have survived eternity,

As the hill and dale remain meditative.

Boasting layers of tales are rocks sedimentary.

The precipices seem to fall into a sigh heavy.

The lyrics of a contemporary song

Take stock of history's receipts in the valley,

"On the first day of 2012."

The climb of the cliffs perpendicular,

Is the Noah's Ark to retrieve its soul

And salvage itself properly.

TRAVERSING THE HEIZI GOBI DESERT

The Heizi Gobi desert is an unpopulated village,

And the bass of the Tianshan Mountains' symphony.

I'm traversing and seeing it with my own eyes.

The snow falls in the winter, flying gracefully,

Trying to kiss the roots of the camelthorn.

The frozen breath gives birth to crystals happy,

As if an entire life's passion

Were devoted to a brief rendezvous.

But some are bent on leaving it with acceleration.

Those inaccessible places

Their spirits cannot dampen.

Traversing the Heizi Gobi,

With a clear and clean heart,

I've planted horses' affections for a prairie.

GOLDEN DESERT POPLARS

Autumn wind sets leaves falling all over,

Only you resist it in a caring manner.

You have thus changed

A specific rule or regulation

Through gentle friction.

The tongue of the sun's conflagration,

Hops on each of the leaves

As if to compare notes with every season.

Ci poets from the Song Dynasty

Conjure up ancient tune names in great variety,

As Monkey King cloned himself in quantity

With the fine hairs of his body.

A contemporary person of vulgarity,

I see the golden color differently.

beautifully coquettish in my eyes,

It subverts thoughts of classic integrity.

FRAGMENTARY THOUGHTS ON FINDING JADE WITH FEET

Along a shallow river flowing gently,
Many dreams bloom in great brilliancy.
Everything, be it humble or noble,
Is basking naked in the sun on its levee.
Tales of nude women finding jade with feet
Tell that they test with their feet gently
Draped in the moonlight faintly silvery.
When a piece of jade gives her foot a kiss,
She behaves as if she found her fiancé,
With a sensation of love hard to dismiss.
For the past hundreds of years or so,
They've waded hanging their pious heads low,
Above, the sun's sutra streamer is Day-Glo.
Into unmeltable fantasies, she transforms
From the Kunlun Mountains' thawed snow.

096 MAY IN KASHI

Drawing the curtain open,

I pushed the window open,

But sand came without invitation.

To prevent its intrusion,

I closed the brocade curtain,

Making the sun feel crestfallen:

Its rays linger on my window sill.

I drew the curtain open again,

But I kept the window closed still.

As the sun popped its head in,

The sand puffed out grey dissatisfaction

Onto each window pane.

TO A KIND OF URBAN BIRDS

Living in a city decent,

It never lacks nourishment.

That's why its singsong

Is always resonant and long.

It can overwhelm all the rustic birds,

But it can't hold its tongue.

The sound waves it's producing

Are like adolescents

Clamoring their fabricated structure.

I want to talk them into

Going for an outing,

Bringing their underdone thinking

To the desert for baking

And turn it into a golden realization:

Retraining in the future from babbling.

THE EAGLE FLUTE

In this place only,
A three-holed bone flute is played
By two people simultaneously
Always in Key C,
Like a fish biting the tail of another.
It's played from low to high notes,
Which then fall as if from the sky azure.
Like emotional melodies,
The fluting has always been in cadence,
As if a tumbling valley river
Destined to defend a kind of resonance.
There's the smell of the sun in the fluting
Because the sun has a part in its boldness.
Over the plateau, the tunes seem to be flying
Because it's the eagle wings' feather shaft
That creates the melodies rising and falling.

FALLING APRICOT BLOSSOMS (CYCLE OF POEMS)

1. Beauty Is Also a Kind of Loneliness

Perhaps it's been pent up for too long,

A whorl of stamens pops out

Like the puckered lips reddish-pink.

I can't wait anymore

For its ephemeral flirtation,

Because I have to green another part of the sky.

I can't get close in time

Or even bend down

To extend my sincere admiration.

The fervor that comes too early

Would expedite the fructification

Of a kind of solitude in too much of a hurry.

I can only gaze with my teary eyes.

In fact, beauty is also a kind of loneliness.

Sometimes, getting out of it

Would cut off the path to absolute beauty.

2. So Dimly Discernable a Figure of a Beauty

It's not true that I didn't search

For you from morning till night,

From the real world to my dreamland.

I, the ancient riverbed did sight;

Almonds met my panic-stricken stares.

I almost misidentified her as you:

Though your heartbeats aren't in sync,

Your elegance she shares.

It was my toes only

That touched you in the mud sticky.

And I felt a shudder

Me running over.

As soon as I looked up,

I saw your fragrance just dashing in the air.

Oh, the Yengisar's apricot blossoms in April,

Why are your figures so dimly discernable?

3. Sorrows of Spring

Sorrows of spring

Finally, make me understand

That it can be so brutal.

Sorrows dance in the sun

Like the tears in my eyes

Shaking like many a crystal.

If all the apricot blossoms have fallen,

What's the point of peach flowers blooming?

Take it, my admiration for spring.

Give back to me a mind unblemished

In the April of 2011,

Having disguised itself cleverly,

The chill sneaked onto a stage lively,

Wounding many of my years inexperienced.

100 SNOW IN A STRANGE LAND (CYCLE OF POEMS)

1. My Homesickness Is Piling Up

On a strange land,

Snow fluttering thickly

Can pile up with ease.

So is my homesickness,

Expanding boundlessly.

Wind disturbs the snow occasionally,

Sending my homesickness farther away,

Tuft after tuft.

Can a few of the flakes duckweed-like

Drift to my hometown dispersedly

And fall upon my folks' attire?

Can they touch the warmth there

And burst into full bloom involuntarily

Like the tears beady?

But more accumulated snow will thaw

Into streams of sweetness dear

To expedite the advent of spring here.

2. I Want to Bring a Handful Back

In cities,

Snow can be either

A landscape or a disaster.

Its flakes are pure white seeds

In places away from home, however.

Plunging into the sentimental ground,

They sow homesickness yonder.

Silence in wintry days

Will be in full bloom the spring following.

I reach out my hands further,

With me, a handful trying to bring.

But they thaw instantly into wet vapor

And vanish without a whimper,

Leaving behind an agony of emptiness

To tug at my heartstrings tender.

Snow in places other than my hometown

Is somewhat exclusive.

So, I can only weave a complex of my own

With the sorrows of a southerner.

3. *Led by the Snow of a Place Not My Home*

Led by the snow of a place away from home,

My eyes embark on a willful inspection.

They sparkle more agilely than snowfield birds.

Hunger empties my mind like poetic composition.

Keeping quiet

Is the state of all vegetation.

Perhaps it must have also been true

Of my former incarnation.

Under the feeble sun nearing senility,

The ravens are cawing

As if it were only clamoring.

The cold weather has frozen everything.

There're luckily still snowflakes spotless,

Together with my eyes dancing.

The dance has resulted in an artistic world

Filtered until it's completely dustless.

4. Bleached Long Night

The snow of a place away from home,
Will whiten my intense longing,
When fallen on my hair;
Will condense into love unreasoning,
When fallen on my brows;
Will become teary sorrows glistening,
When fallen on my lashes;
Will change into butterflies dancing,
When fallen on my garments.
The snow of a place away from home,
Has bleached the night long-lasting
And wetted the wings of my dream.
Broken pieces of clouds are drifting
In the sky shared by my hometown.
When will the fullness of the past
Set its mind on returning?

5. Running Like Sheep

The snow dances and hops

Like a flock of running sheep.

Even if the moving order were premature,

They shouldn't have been rushed with rapture.

Or were they penned in the sky for so long

That they have to leap and bound headlong?

A figure anxiously flying in circles

In the misty snow of a strange land,

With them, my mind is running along.

When to the ground, it drops down,

Smiling as it snuggled against the snow,

My homesickness finally calms down.

6. Like My Childhood Buddies

For the past few days,

The strange land snow has lingered

Like my childhood buddies

Waiting quietly outside my house,

Joining me in revelries unhindered.

I cast my homesickness unshakable

To a corner of a freezing street

Or among fallen leaves almost sable.

Like my infant name

Called gently,

Broken memories are barely discernable.

A kind of freshness

Lingers for a long while

Like clouds of kitchen smoke

Circling up from the roof of my domicile,

As if to portray the hometown soul.

Peaceful plumes

Lick the dynamic wind tenderly.

Though the night is getting late,

Like moonlight, they're still white silvery.

7. Who Can Read the Confused Mind of a Strange Land's Sky

Who can read the helter-skelter mind

Of a strange land's sky except for

Her pure white, name, and coldness of a kind,

Which has frozen your steps for ages?

You can't move around,

Trapped in her silence,

Snow falls razor thin.

In cities immense,

Loneliness is also as thin as paper,

Which will soon be crushed into the mud

By wheels rolling over it in disorder.

I know what's on my mind

Doesn't relate to any appellation or color.

Will it become thicker

In the starry sky tomorrow

After hiding a city in the snow.

8. There're on Land as Many Sojourners

There're on land as many sojourners
As snowflakes falling from the sky.
Aren't they hometown messengers?
Bringing a pure-white longing for me,
They come for a visit with affection
And learn if everything goes smoothly,
If I've found my desired direction.
Or if I've heller-kelter crashed
My warm yearnings to many a fraction.
The ground receives them for their worth
To none the responsibility she's shuffling.
She takes them into her ample bosom,
To all sojourners, a home she's providing.

101 A MOVING MOUNTAIN

Mobility has created this shocking beauty,

And who's solidified the once-dynamic valley

In a moment that's stayed static for eternity?

This fantasy also spurs annual rings to overgrow.

Each mountain has a story of its own to tell,

Each of the tales is the shadow of humanity.

Hiking in this valley,

I want to make my hardened days

Livelier through walking.

The solitary gully

Is full of curious eyes.

I, a man coming from a city,

Full of stories,

Resemble a moving mountain Precisely.

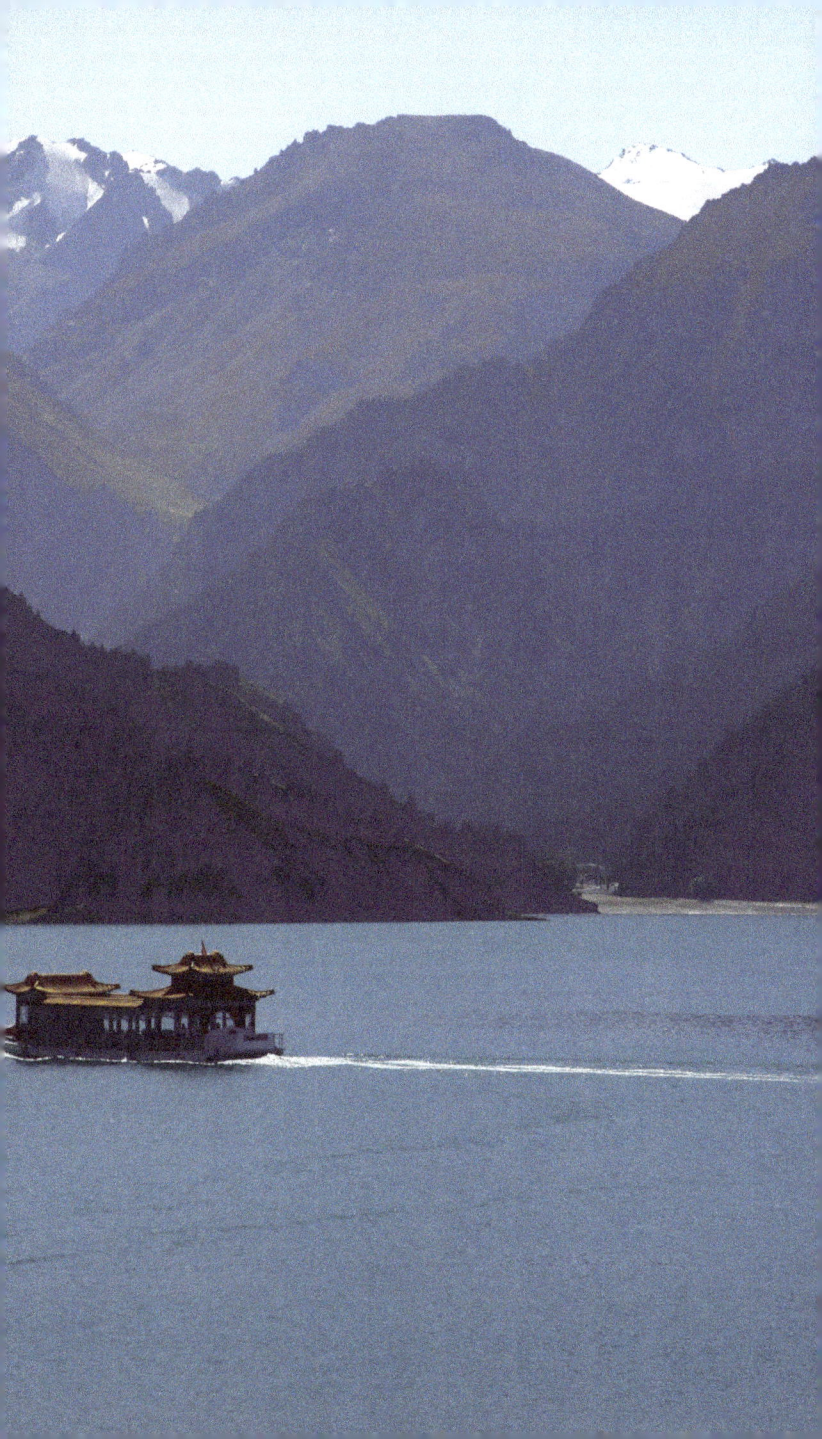

BOSTEN LAKE

I call you a lake,

And you're a lake.

Fish quietly swim under your ripples,

Reeds grow along your shore endless,

And lotus flowers bloom with sunrise.

I call you a sea,

And you're a sea.

Snowmelt startles lapping waves.

Though the water area is boundless,

I can hear your howls and whistles.

Whatever you're called

Is as fleeting as the wave foams.

Why do we have to fight over trifles

And care so much?

Oh, Bosten Lake,

If your grand and natural simplicity

Is protected duly,

You'll be saintly,

And invulnerable to humility.

A YARDANG

A Yardang Landform,

Carved by wind and water,

Is the mountain crags' portrayal

And people's unconcealable makeup facial.

On the perfectly straight highway I'm standing,

To size up the outlines and patterns flanking,

My thought winding and meandering

All the way back to where I came.

It even goes beyond

The ridges and valleys rolling.

Time has eroded many a precipice

And sculptured solitary desolation.

It's sometimes jutting out,

Like a divine demeanor appearing.

There's nothing to worry about,

Human life's vicissitudes including.

PUTTING UP THE NIGHT IN SHACHE

I haven't written any poetry for her,

Though I attempted thirty-three times.

She's too ancient for me to have her

In my dream on a scale of grandeur.

Perhaps I'm being over-sentimental.

I was too busy to enjoy Muqams today.

Nor to eat apricots did I remember.

But they came crowding around me,

Like uninvited doves that flutter.

Bound to lose my sleep tonight, I entrust

Yarkent Khanate's capital in times yonder

To the wings of my dream for a time.

When the moment of marital bliss comes,

With me in a rejuvenated manner,

It'll spread its wings wider.

A RIVER TRAVERSING THE GOBI DESERT

The water born of a noble family,

Tumbling all the way from the glaciers.

Tearing apart the wings blocking its passage,

It comes stark naked,

In order to cross the Gobi over

To the desert world with fervor,

Enabling ages of silence to sing in glory.

Salt cedars gaze at it with affection,

As needlegrass greets it in a lineup.

The zigzagging paths yonder,

Resembling undulating strings

Produce tune after tune tender.

It finally turns into a tiny stream,

Like a lamp wick before briefly smiling

At the moment when it submerges into the sand,

As if at the sun mischievously winking.

106 A FLOCK OF SPARROWS

Having fallen half a month ago,
Clinging to the ground of the city
Is the remaining snow.
Heavily guarding it
In an ambush on all sides, it's waiting
As if to expect something in suspension.
A flock of sparrows is flying over.
Twittering and moaning,
They forage and look for places to perch.
That scene breathtaking
Is perfectly delightful.
With black dots on the white background,
It's a painting indescribable,
The beautifully cold nature ink-washing.

SNOWFLAKES

With white flames, I'm still burning,

Even knowing love is but a legend.

When it falls profusely fluttering,

Like a glacier of a millennium,

It slides down the hillside,

With the sound of ice sizzling

And will eventually dry up.

Like my yearning for the world,

Again and again, it's dashing,

Then over and over, it's tranquilizing.

It whitens a frontiersman's pen

And melts a millennium of homesickness.

Flying and running,

The land quietly swallows it;

Its temperature is ever-changing.

108 SPRING OF A THOUSAND TEARS

If rocks could shed tears,

Lovesickness would last for years.

A spring came from the Kucha Kingdom,

Not discarding its haughty airs.

Pure and clean, all the way it did come,

But where did it end up in the end?

Vanishing without making a ripple,

It refuses to tell where it would bend.

Just as we can't keep our fantasy,

So reality, like the sun's hands,

Can always drain life's poetry.

Oh, my surging infatuation

May have turned into an insects' twitter.

If a tear is as good as a year's chirp,

A millennium of tears will finally wither.

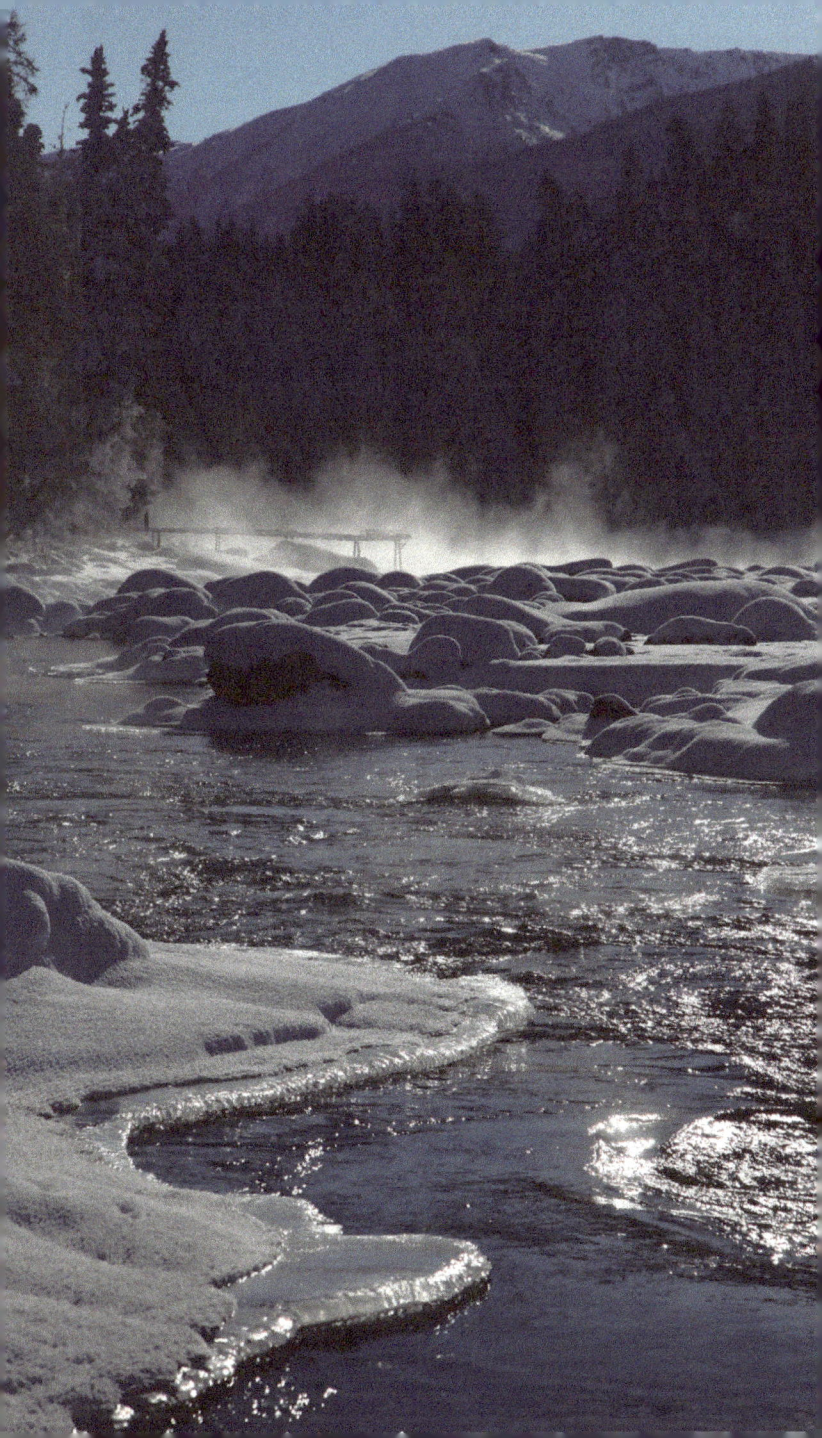

THE LOST HARVEST

Who says the loss isn't beautiful?

For Kanas Lake,

Loss is bountiful:

It lost the concept of sanctity;

It lost the path of sanity,

It lost the composure of thinking,

And it lost the trouble of prudery.

I lost my camera, so I had to place Kanas

Under the wings of my fancy.

I lost my past so that Kanas

Will be the days to pick up consequently.

Hey, Kanas,

How about losing me?

Then, I wouldn't have to expect

Those poems of sincerity,

Like sails, to plow a furrow

Through your brooding tranquility.

110
THE REMAINING PURITY

It's the very last drop

Of Creator Pangu's tears,

Solacing our souls.

The overdrawn desire

Has long drained the tears,

Blearing the heaven and earth's marker.

Without some abstinence,

Or, for this teardrop, a little veneration,

What would we have in our preservation

To enable us to have a clear conscience?

I weigh the teardrop in my mind:

It's like the bright moon aloft,

Always seen as an evil-detecting mirror.

Oh, humanity,

How can you, in the dark, still slumber?

LAKE OF DREAM

The chill of the early autumn can't decrease

The burning desire for nearing this sacred lake.

The band of clouds surrounding it with a breeze

Has formed a bridge,

An offspring of their compromise not with ease.

My eyes follow closely

A limpid hope

clamoring in footfalls unnoisy.

Instead of walking,

I'm flapping a pair of wings of purity

As I invite myself into this wonderland.

It's the first time deep into it myself I find,

And the Lake of Dream has since stuck in my mind.

THE FIGURE OF A SPOTTED DEER

Where is that intelligent spotted deer?

Many years ago,

It brought a shepherdess dear,

Like a drifting pure-white cloud,

close to a hunting lad.

Many years later, its blood

Found its way in their baby's body,

While its own has vanished since,

Together with its agility.

I've been looking for it hard,

Like a bird clumsy,

Hopping from that col

To the lakeshore.

Like a mass of clouds fluffy,

The lake lights up my field of vision.

I see the beautiful, mysterious deer clearly

Perching nonchalant in front of me.

CHUER'S DREAM GROANS

Chuer is said to be the *hujia*.

Its handsomeness is heavenly,

Infatuating a proud princess.

In the night no longer reserved,

She listens to it attentively,

Her eyes that caress the flutist

Were as profound as the lake.

No one can resist

The tenderness of its limpidity.

A love affair is but a fairytale,

After which comes

A faint sense of melancholy,

Occupying the mind like mists.

You may go to the Kanas lakeshore,

And listen quietly

To the dreamlike *chuer*.

It sounds like groans dreamy.

A LAKE WITH SIX BENDS

Kanas Lake comprises six bends,

Each like a flute's finger hole.

Playing a magic piece of music,

Quiet grandeur they extol.

I dance on these finger holes,

Making the tune touch me more.

I don't know if I'm a note tiny

Or a shepherd boy singing freely.

I splendor the world I met ages ago

With my most unrestrained reverie.

The night may be more lovely,

With the moon being the seventh hole.

The addition of the flute's lucidity

Would stimulate my insensitive soul.

AS NOBLE AND UNSULLIED AS THE SKY

Even boasting such a peaceful nature,

You can't decline an erratic goddess' crown.

All the elements of the climate

Have plotted to make you dreamily demure.

Like a fashion model cat-walking

On the runway shone by the sun

Only to set off the clothes stunning.

Beauty becomes a pricey hanger

And applause only proves showy clamor.

I can see everything abundantly clear:

You're as noble and unsullied as the sky,

Your wide-open heart that none can smear.

Lies at the fathomless bottom of the lake.

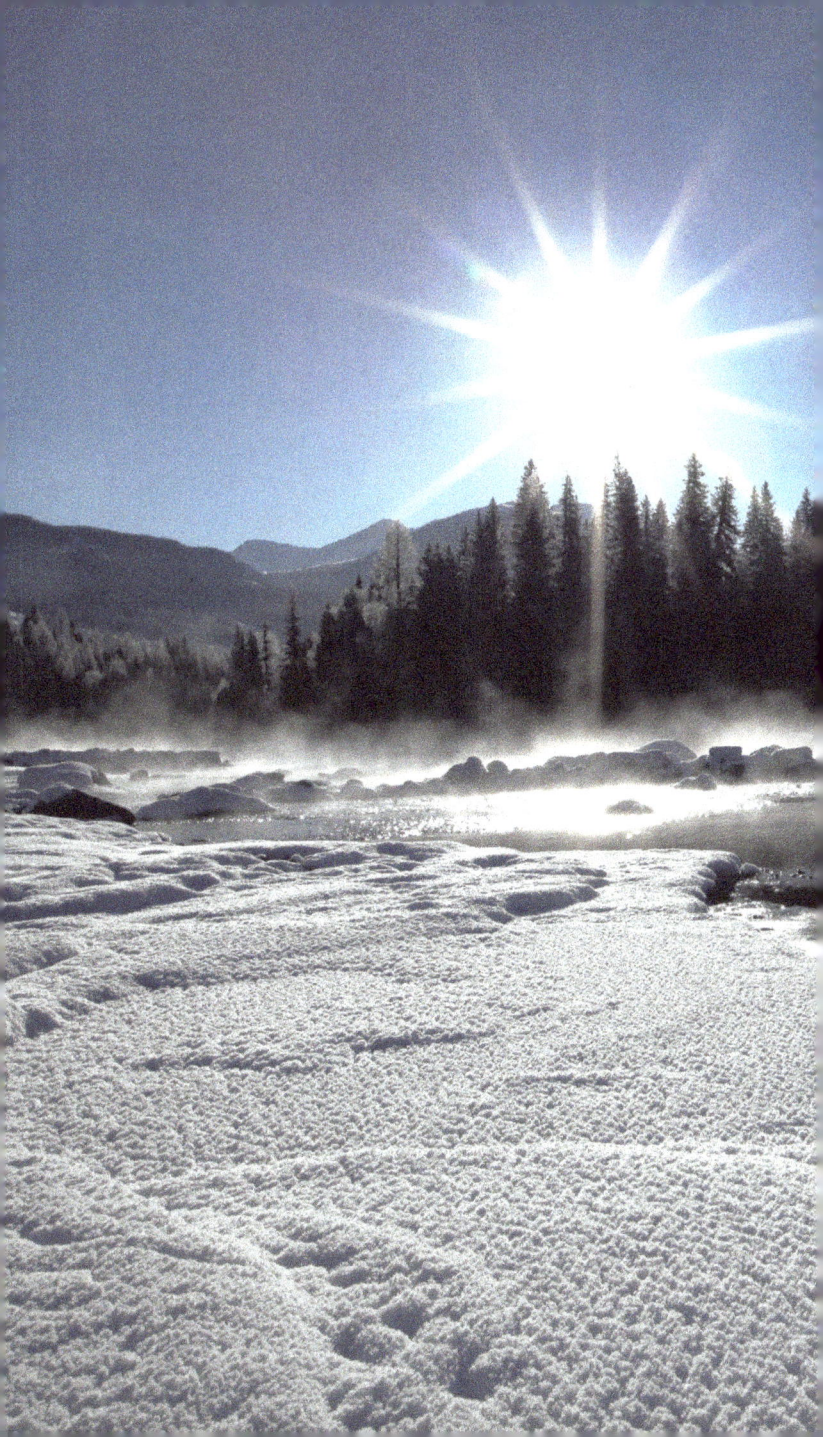

116. HEAVENLY LAKE OF TIANSHAN (CYCLE OF POEMS)

1. An Elm Grove in Summer

Elm groves become tender in summer.

The caressing hand of the star solar

Make the graceful and enchanting lines

Smile with the wildflowers by a gully river.

But facing the masculine bitter cold,

She can exhibit her enormous dignity,

Though she appears strong in winter.

She's filled with wishes for dreams tender

As well as high spirits unyielding.

No matter which season presents itself,

It's a time when temperament is flying.

A bright crescent moon wrapped up thither,

The sun, with its form and color, is repaying

Going hot and cold by turns is the sun yonder.

2. The Surface of Tianchi

Tianchi, with her stoical face,
Received the uninvited me once,
On a bitterly cold day.
Instead of turning away,
I set my feet on its surface
Along with my stalwart body.
The hardened face is a language,
I know I'm unlisted in its upset lexicon.
Therefore, I came again in summer,
When it gave me a rippling smile,
So mesmerizing that it evokes imagination.
But treating everyone in the same manner,
She ostensibly ignores my frustration.

3. Those Loitering Clouds

Those loitering clouds are being too calm.
They aren't disturbed whatsoever
Even when Tianchi they encounter.
I pursued them to the Guodikeng Formation.
They saw me as a five-needle-pine in a col.
I can only tell they're of the Buddhist religion,
Dispassionate about us chanting poets.
If a gust of wind should spring up now,
I want to see their panicked expression.
Their aristocratic-looking demureness
Is vulnerable to repeated provocation.

4. It Takes Me for a Tuft of Cloud

A sheep covered in green wool,

A scrubby bush does resemble.

Standing on a crag by Tianchi,

It makes a fantastic spectacle.

The steps I take as I approach it

Carry a city's hustle and bustle.

But it seems undisturbed whatsoever;

So is the lake's reflection in its eyes.

It doesn't appear panicky,

In the face of a stranger,

Who's invading its territory.

It must have taken me for a cloud

Coming from a strange place.

But it always has time to stop

To share with it the peace.

5. *Snowfield Buick*

Snowfield Buick is the name

Of a stalwart man, traversing

The land between Tianchi and Fukang,

As pure as the mountain clouds drifting.

His yurt has a strong smell of milk tea,

My nostrils and my dream assailing,

Refusing to dissipate.

And the stories about him,

Up and down the mountains tumbling,

Resemble the col's stream gurgling,

Crystal clear and glimmering.

That day,

I meant to introduce a newcomer

To him as a friend.

But I couldn't find him any longer.

He may have moved his flock somewhere else.

www.ingramcontent.com/pod-product-compliance
Lightning Source LLC
Chambersburg PA
CBHW040111180526
45172CB00010B/1300

9781616121419